APERTURE

Photostroika: New Soviet Photography

With the advent of glasnost, the invisible materializes; the forbidden is tasted for the first time. We expect a great deal from Soviet photography—the sweeping passions of the October Revolution and *Anna Karenina*, the redoubtable spirit that has kept an underground artistic culture alive, the colossal determination that from a feudal culture has led to the exploration of space. "These are new times, and new times call for a new style," Sergei Zalygin, editor of the leading cultural magazine, *Novy Mir*, has said. "Our artists are looking for one . . . they haven't found it yet."

The Soviet Union has long held for the United States the fascination of being "the other," both mirror image and implacable enemy. This myth has endured in large part because our information about the Soviet Union has been so sparse. Now glasnost has brought us the voices of Russian mothers weeping for their sons in Afghanistan as Americans did for the dead in Vietnam; upheavals in Azerbaijan and the Caucasus for minority rights remind us of our own racial divisions.

The decade following the October Revolution marked a time of artistic flowering, as new techniques, including photomontage and multiple exposures, enabled art to serve as a metaphor for a dynamic social and political reality. Artists such as Alexander Rodchenko, Sergei Eisenstein, and others used photography and film to construct events, rather than simply to reflect them. With Stalin's ascent to power, though, such radical experiments in new ways of seeing were suppressed by administrative decree. Despite severe governmental constraints, some photographers were still able to produce significant work in the ensuing years, notably the brilliant photojournalists of the war years—Dmitri Baltermants, Eugene Khaldev, and others.

A central struggle in the Soviet Union today is to redefine the past. Images and texts of the last twenty years have begun to emerge from the locked drawers and secret hiding places where they had been stored. Meanwhile, writers and artists spend their time in political activity—speaking, reading, said Zalygin, "not writing novels and poems—but writing journalism!"

This issue presents a surprisingly diverse range of recent work by significant Soviet photographers as they attempt to articulate visions appropriate to the radically changed circumstances they, and the Soviet Union, find themselves in. Whether the lyrical color street photography of Boris Savelev, the ironic handcolored images of Boris Mikhailov, the romantic black-and-white work of Lyalya Kuznetsova, or the dreamlike nudes of Peeter Laurits, these photographs indicate a new direction in the tangled history of Soviet art and life.

Barba idyot, the struggle goes on, is a phrase heard daily in the Soviet Union. No one could have predicted the swiftness and drama of recent changes. Already Western observers are hedging, warning of a backlash from increasingly resistant apparatchiki. But perestroika will be hard to stop, and its results impossible to erase. Its fruit may not be seen until the next millennium—and what new images can we imagine then?

THE EDITORS

Armed Only with a Camera: An Interview with Dmitri Baltermants

Dmitri Baltermants achieved worldwide fame with the moving combat photographs he made during World War II. Since then he has continued to occupy a leading position among photojournalists in the Soviet Union, and today serves as a member of the editorial board of the leading news publication *Ogonyok*. When he was asked to participate in this issue of *Aperture*, Baltermants agreed to be interviewed by mail. What follows is the result of that exchange.

Aperture: In the early years of Soviet photography there was debate about the proper uses of photography between the October group (Alexander Rodchenko, Boris Ignatovich, and others) and the ROPF (Union of Russian Proletarian Photographers group, which included Max Alpert, Arkady Sheikhat, and others), and strained relations between the two factions. Did you take part in those debates? Where did you stand in them?

Baltermants: My position in the dispute—a controversy which I consider to have been a sign of the times—was ultimately related to the things I learned about from the great figures on both sides of the debate. From Rodchenko: the importance of the composition of the frame, which one well-known writer described as "beauty, not obtained as an inheritance, but created by man." From Arkady Sheikhat: the skill to be an artist-publicist. And so on and so forth.

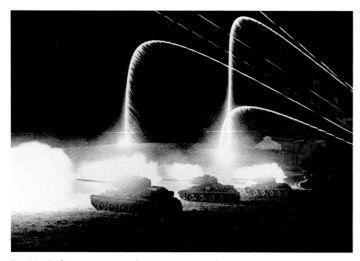

Dmitri Baltermants, *Tanks Firing at Night*, 1943

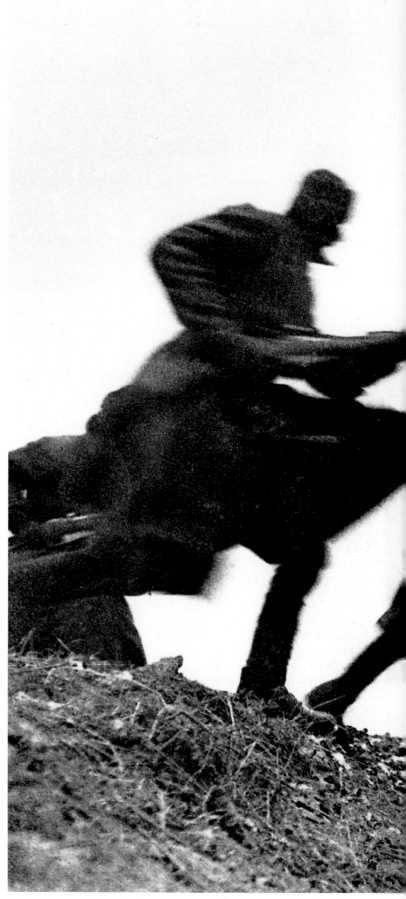

Dmitri Baltermants, *An Attack*, 1941

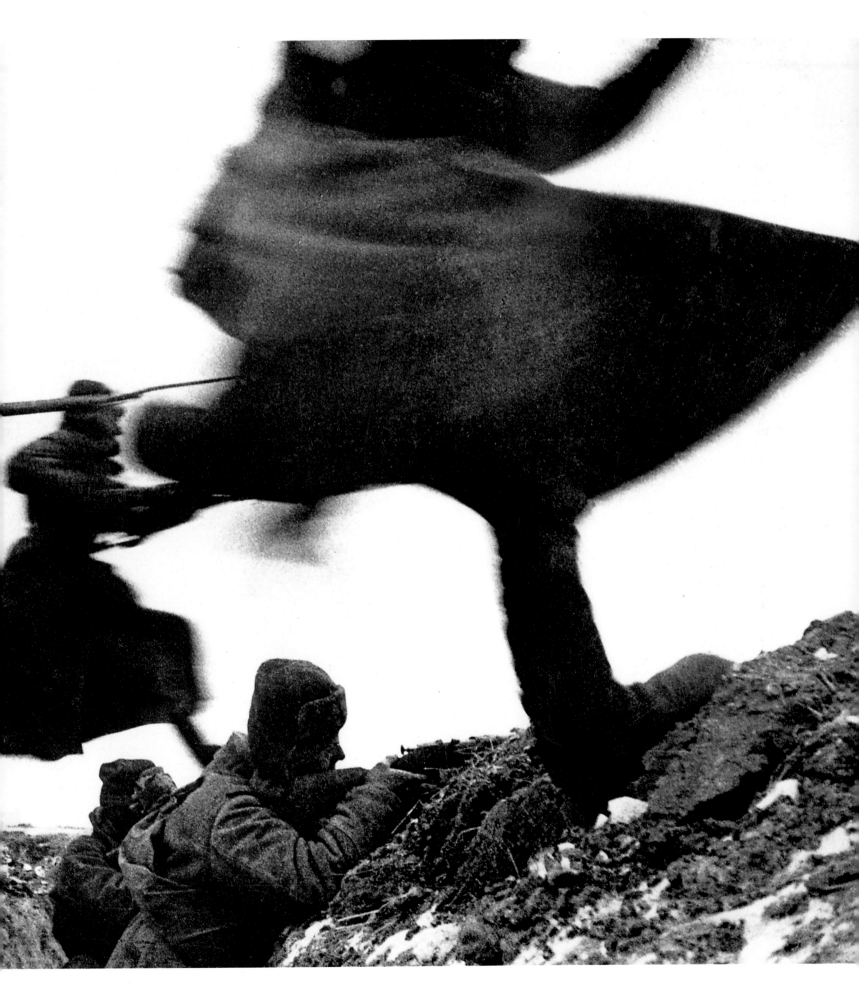

Aperture: Is photography in the Soviet Union recognized as an independent art?

Baltermants: And in regard to the recognition in our country of the art of photography—the process has been a long and painful one, and has provoked the opposition of our orthodox artists. Although it had been announced long ago that photographic art does exist, in order for this idea to be given critical weight, it was important for capable writers who loved and understood photography to come forth. They were the ones who were faced with the task of laying the theoretical foundation for the medium. And this is a process that is still going on.

Aperture: Can you describe your work as a photographer during World War II? Were many of your pictures published during the war itself? Who were some of your colleagues?

Baltermants: Robert Capa, the photographer who became the model for war correspondents everywhere, wrote about how difficult it was for him to master the skill of photographing war. In fact, he wrote, he would have been happy if he had ended up as an unemployed wartime reporter. We Soviet photographers also went off to war "untrained." Many died bravely. Only many years later, after the end of the war, did it become clear how many magnificent photographs had been made on the fronts by our photographers.

Most of the wartime photographs, though, were not published in the Soviet press during the war. Petty officials of art, who decided in accordance with their understanding of things what to print and what to prohibit, stood in the way. To some extent, I suffered from these same restrictions. Today, though, these magnificent photographs have begun to appear in exhibitions and journals, telling of the courage, grief, and suffering that war brings. But many of the photojournalists themselves, who fought armed only with their cameras, have departed from this life. We preserve in our memory the names of M. Alpert, G. Zelma, M. Redkin, and many other companions-in-arms.

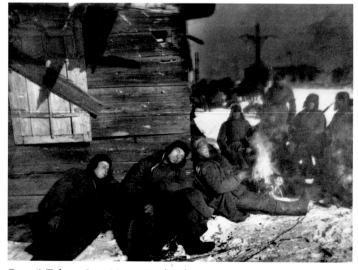

Georgi Zelma, *In a Moment of Calm*, 1941

4

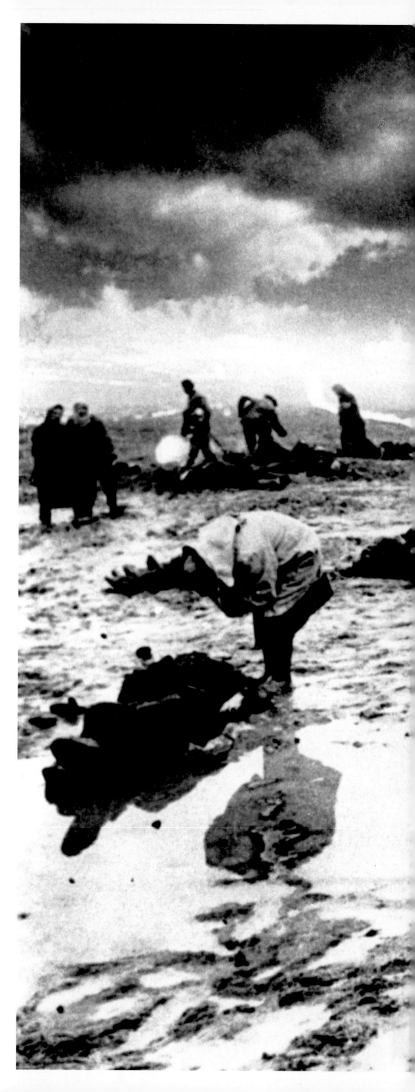

Dmitri Baltermants, *Grief*, 1943

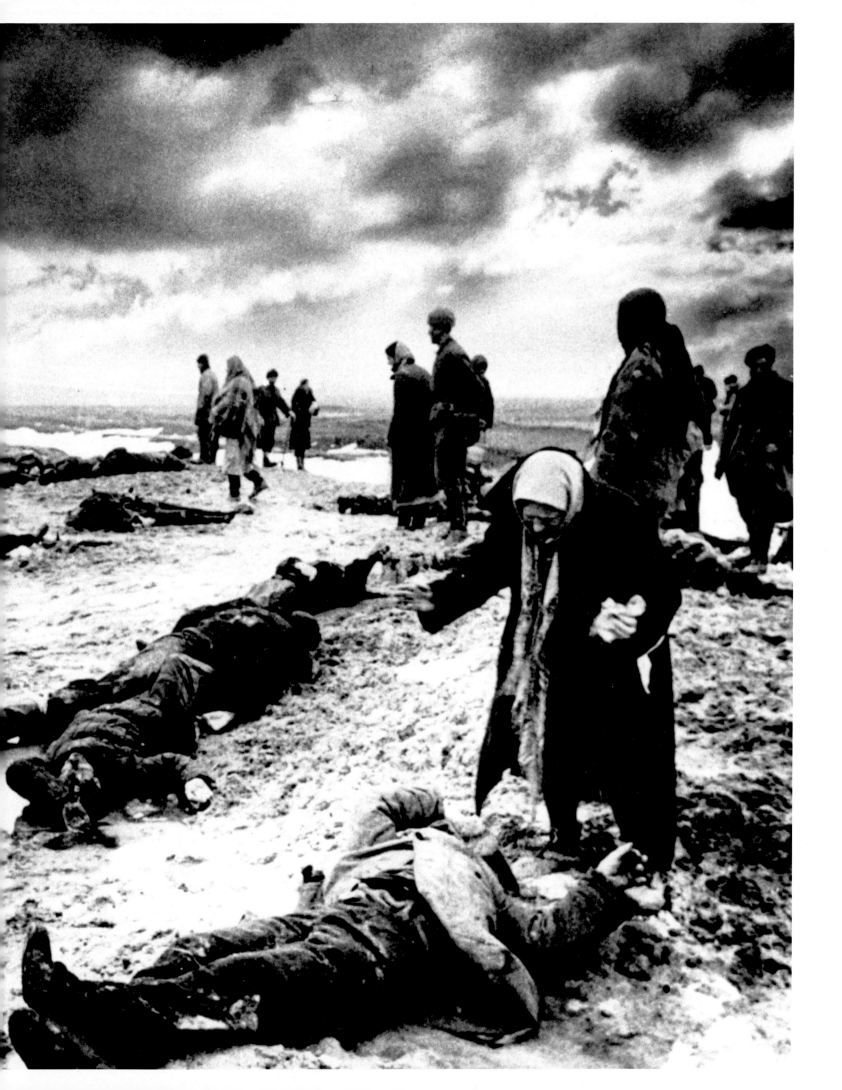

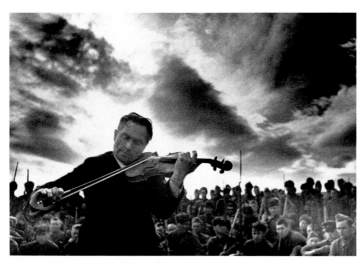

Anatoly Garanin, *Professor Ilchenko of the Moscow Conservatory performs before soldiers on the Southern Front*, 1942

Aperture: Were you and other photographers in the Soviet Union aware of the work of photojournalists in the West, particularly for magazines?

Baltermants: The mass picture magazines, in which photography occupied a special place, played a very important role for me. *Life, Paris Match, Stern, Der Spiegel, Berliner Illustrierte Zeitung* and others all contributed to a reverent attitude toward photographs and their makers, setting high standards for photographers around the world. The pictures published in these journals provoked naked envy among us toward the photographers whose work was included there.

Aperture: Have you had much occasion to meet and exchange ideas with photographers in the West?

Baltermants: Such encounters with the masters of the art of photography did take place. Over the years I have had about twenty one-man shows in various cities throughout the world. I have met and am on friendly terms with the leading exponents of world photography. This is both heartening and creatively enriching. I will always cherish the memory of meeting Ansel Adams, the great American photographer. I was fortunate enough to be with him at his home not long before his death. His book, which he signed for me, occupies a place of honor in my collection of photography books.

Aperture: A final question: what do you think is the situation of photography today?

Baltermants: We photographers make magnificent shots of wars, fires, earthquakes, and murder: the grief of humanity. We would like to see photographs about joy, happiness and love, but on the same level of quality.

I realize, though, that this is difficult.

Translated from Russian by Alexandar Mihailovic.

Dmitri Baltermants, *Road of War*, 1941

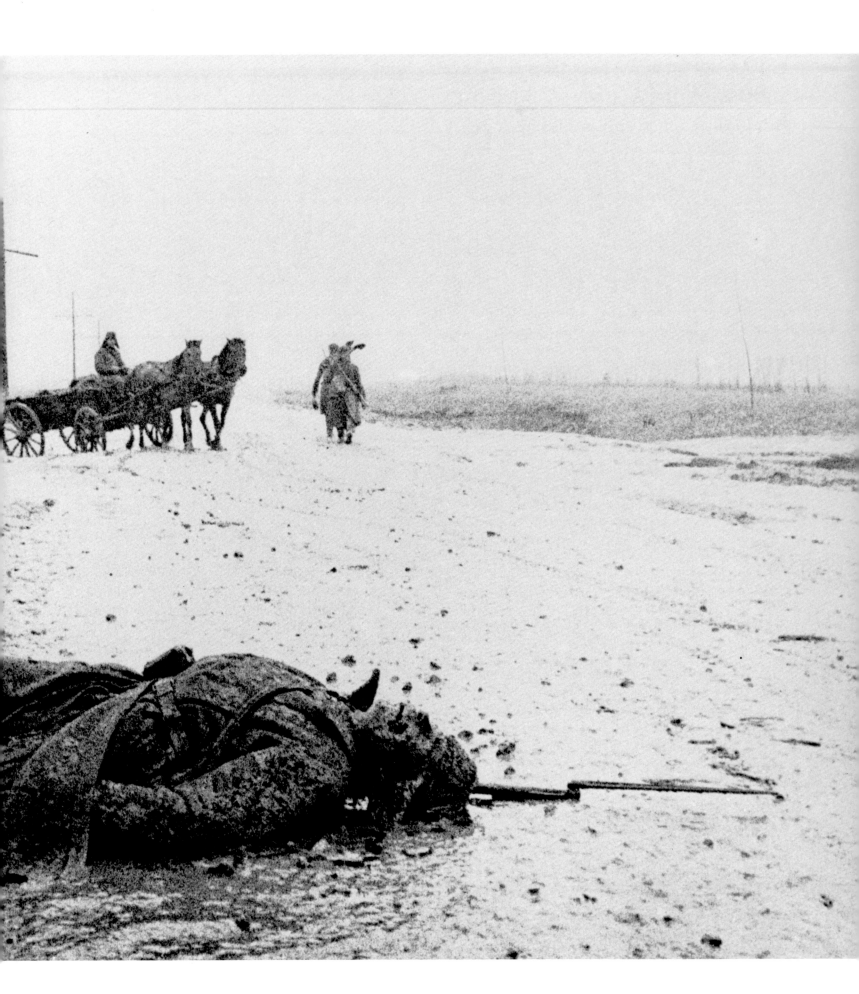

No More Heroic Tractors: Subverting the Legacy of Socialist Realism

by Rosalinde Sartorti

What is it that makes recent Soviet photography so fascinating to a Western audience? Is it that, for the first time, Soviet people and Soviet society look familiar to us? Or that these photographs show the same kind of loneliness and emotional emptiness characteristic of any modern industrialized society? Or is it that the different photographic styles we see now finally suggest a liberalization in a society that until recently had rigidly controlled its cultural sector?

It would be unfair to judge these new pictures by Western standards. They are the result of specifically Soviet traditions and a specifically Soviet way of seeing, of which we know very little. Since 1932, when the various associations of Soviet photographers who in the 1920s had developed different ways of depicting reality were abolished by administrative decree, the Soviet people have been exposed to what was called "proletarian photography," the equivalent of what came to be known in literature as Socialist Realism. Since that time the pictorial code of Socialist Realism has been the only officially sanctioned style of visual representation in the Soviet Union. Photographers were instructed to take pictures that anticipated the future, "to show in the light of today the contours and contents of tomorrow."[1]

Socialist Realism was not only a style, but above all a range of subject matter: workers, peasants, motherhood, brotherhood, birth and death, the rites of the life cycle. It favored events linking the individual to society, private events of a public nature: the first day of school, becoming a pioneer or a member of Komsomol, graduation, marriage, and so on. Under Socialist Realism, Soviet photography was limited to the portrayal of so-called universal values: love, friendship, happiness. It depicted a world of harmony, of happy workers and happy peasants, and, at the same time, a world of heroes. Even the hardships people faced were made to look heroic. The dark sides of everyday life—of which there have been many, throughout Soviet history—were shown only in pictures of the West, offered as proof of the superiority of socialism over capitalism.

It was only in such pictures that Soviet citizens could find the land of happiness they had been promised by the October Revolution. For many years Soviet photography, freed from the contradictions of social and political reality, was used to shore up highly fragile social structures. Photographic images in the Soviet Union were not judged according to whether they provided a true or false picture of reality, but were used to create a reality of their own.

Breaking with the clichés and conservatism of this earlier style, the new photography shows spheres of Soviet life that until now have been totally excluded from pictorial representation—prison camps, psychiatric wards, old age homes, and the world of drug addicts. Turning the conventions of the old order on their heads, the new photographers add a touch of irony to the recycling of Socialist Realist images and clichés: glorified Soviet heroes are pulled down from their pedestals; the happy smiles of kolkhoz women turn into grim and tired looks; man, who in Socialist Realist jargon is "in the center of everything," is marginalized, pushed to the side of the picture. What at first sight might be considered simply a deconstruction of Socialist Realist principles ultimately leads to a realist depiction of Soviet society.

For the first time photographs incorporate objects and scenes that have no immediately obvious meaning, but which are open to interpretation and imagination. The Socialist Realist dictum that every picture must convey a clear, moral message has been overturned. The photographers' newly rediscovered joy in graphic forms and lines recalls the playful depiction in early avant-garde Soviet photography of the contours of the human body or of geometric industrial structures. Along with this freedom to explore has come a renewed interest in the human body—revolutionary by Soviet standards. A picture of a nude man or woman might not be surprising to a Western audience, but for the Soviet public, such a picture represents an outcry against long-term and widely pervasive sexual repression.

For anyone familiar with the history of Soviet photography the current situation recalls that of the 1920s. More than sixty

Boris Mikhailov, from the series "Soc-art," 1980—89

Boris Mikhailov, from the series "Soc-art," 1980–1989

years ago, in 1928, a few Russian avant-garde photographers—the most prominent among them being Alexander Rodchenko—began to wage a kind of war against the "traditional way of seeing." For them, the traditional way of seeing meant looking at the world as it was depicted in realist painting, seen straight ahead, neatly framed, fully detailed. In photography, this also meant looking at the world with the camera at waist level—from what Rodchenko called the navel viewpoint.

Convinced of the revolutionary effect that industrialization would have on the future of society, Russian avant-garde artists in the 1920s strove to revolutionize the ways of seeing in a parallel way. As Rodchenko argued in 1928, "We must seek out—and we shall surely find—a new aesthetics, able to express in photography the aspirations and pathos of our new socialist reality." The new industrial society required a new consciousness; in this context, photography was "the new and perfect means to discover the contemporary world of man's science, technology, and everyday life."[2]

The unusual perspectives, close-ups, and dynamic viewpoints that were part of the new aesthetics of estrangement were all intended to break through unconscious habits of seeing. "When I picture a tree, looking up at it from below, as an industrial object, a chimney—in the eyes of the petite bourgeoisie and admirers of traditional landscapes, this is revolutionary," Rodchenko wrote. "But in doing so I enlarge our knowledge of ordinary, everyday objects."[3] In their fascination with the beauty of machines and with the amazing affinities between nature and technology, the photographers of the Soviet avant-garde resembled experimental photographers in the West. Some of their pictures recall the work of photographers belonging to the Bauhaus (László Moholy-Nagy, for instance) or to the Neue Sachlichkeit (Albert Renger-Patzsch), many of whom were themselves influenced by the radical experiments of postrevolutionary Soviet art.

However, in the Soviet Union the "new vision" did not imply simply adapting aesthetics to the new industrial era. It had an even stronger sociopolitical dimension: it set out to teach man to look at the world from all possible angles, from an "industrial" viewpoint—which, for the avant-garde, was the same as a socialist viewpoint. "What's the point of giving a general view of a factory, viewing it from a distance, instead of looking at it closely, from inside, from above, from below!"[4] Objects were not there to be contemplated but to be analyzed; the dynamics of their construction was thought to express the dynamics of the nascent socialist society.

The photographs and picture-series produced by those avant-garde artists shocked and fascinated the public, not only with their oblique viewpoints and unusual perspectives but above all with their energy and freshness in portraying the new socialist society. Still, it was mainly an intellectual elite who reacted so positively to their work; the vast majority of the Soviet people found them incomprehensible.

Socialist Realism's revival of traditional principles in the arts undoubtedly satisfied the visual conservatism of the majority. However, its synthetic vision of the world, declared by the party to be the only true vision, masked the conflicts inherent in the process of industrialization while at the same time depriving the Russian people of the possibility of developing an analytical and hence critical way of seeing. Photography, at one time seen as the only means by which to keep pace with an ever-changing industrial world, became instead a way to portray a static and timeless world.

Many artists and government officials believed that in order to achieve their goal of revolutionizing visual thinking it would also be necessary for the masses themselves to take up cameras. Thus, in 1925 Anatol Lunacharsky, the Peoples' Commissar of Enlightenment (the equivalent of a minister of education), proclaimed that in the Soviet Union "we shall not only have general education, but also general photographic education, and this is going to come about much sooner than the skeptics would believe." (*Sovetskoye foto*, No. 1, 1925). Only three years later the party decided to transform the amateur photography movement into a photo-correspondent movement, through which the Soviet amateur would "no longer take pic-

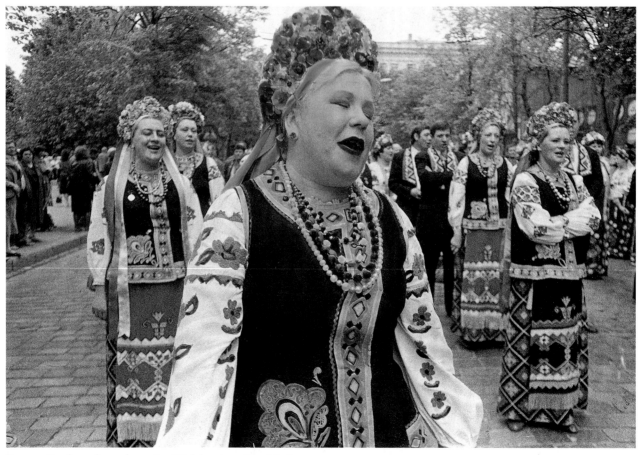

Roman Pyatkov, from the series "Celebrations," 1988–89

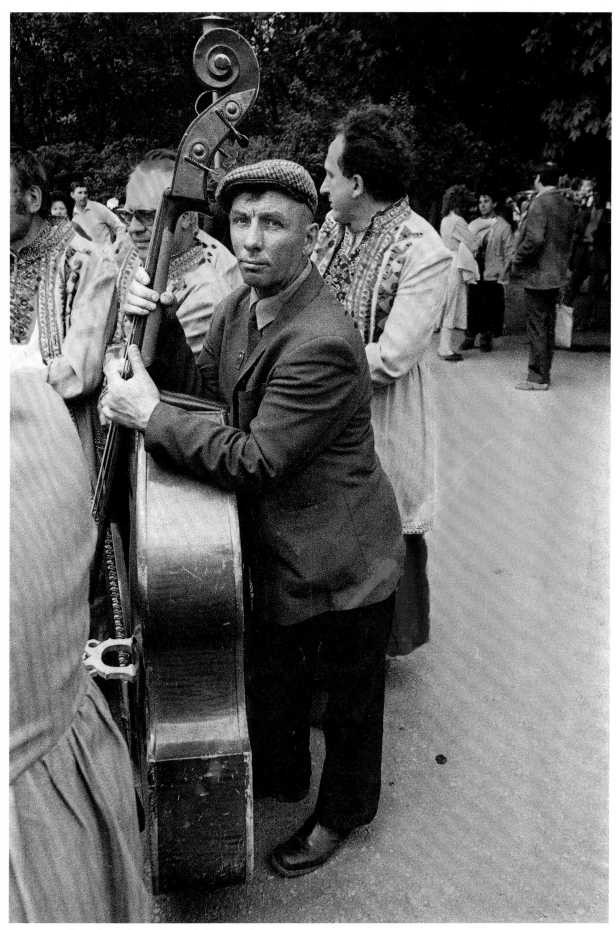

Roman Pyatkov, from the series "Celebrations," 1988–89

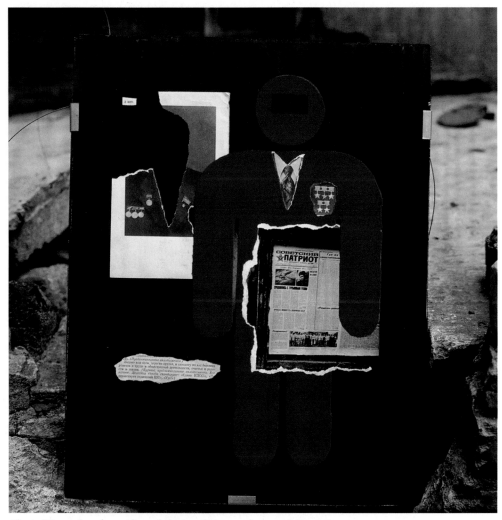

Alexis Titarenko, from the exhibition "Nomenclature of Signs," 1989

tures for his gold-embossed family album, his private collection, or exhibitions. He would photograph for the press." (*Sovetskoye foto*, 1928). This program, however, failed because of material shortages.

Ever since the October Revolution, Russian photography has been crippled by technological problems. Both a shortage of cameras and other photographic materials, and the poor quality of what little has been available, has turned picture-taking into a constant struggle to overcome technical obstacles. Even today, most people continue to rely on studio photographers to record the important occasions of their lives. Limiting the taking of pictures to special occasions not only influences the

choice of subject matter, but also affects the individual's attitude toward the medium itself. Taking a photograph involves preserving a moment for eternity, making time stand still. However, if the moments to be photographed are limited to officially sanctioned events, depicted in officially sanctioned ways, then taking pictures becomes a restricted and almost sacred procedure.

The new avant-garde photographers are challenging the old order. They don't explicitly wage war against traditional ways of seeing; they simply take pictures of a different kind. Many professionals have practiced photography of this sort for over a decade, secretly taking pictures of the world the way they

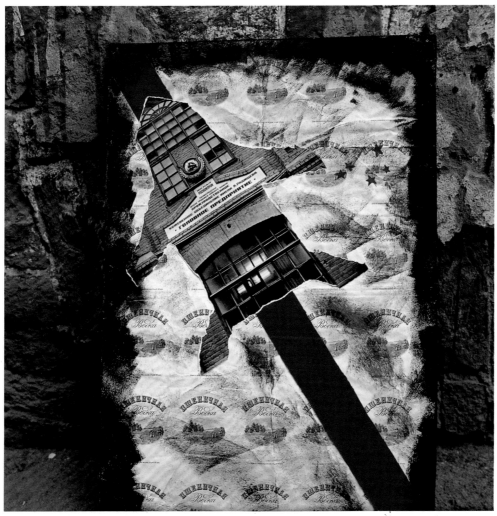

Alexis Titarenko, from the exhibition "Nomenclature of Signs," 1989

saw it, not the way they were taught to see it. Yet it is only since the coming of perestroika that these pictures have slowly begun to make their way into the mass media. Not only did Soviet amateurs continue to take pictures for their family albums, but in the years following Stalin's death professional photographers themselves started to pursue their own private work. It is these pictures that are now being taken out of desk drawers, pulled down from closet shelves, to be shown publicly for the first time in the heady openness of perestroika.

To what extent is the so-called "new Soviet photography" simply a reworking of the old avant-garde slogans, mottoes, and intentions? The avant-garde of the 1920s was attempting to construct a new society, and they did so full of optimism and convinced of their mission to change the world. By contrast, the photographers of the 1980s are far less militant. Perestroika has brought forth no aesthetic manifestoes, no public disputes over the right way to serve the people. Rather than expressing great hopes in the new dynamics of society, the photographers of the '80s convey disillusionment, and no ideological message other than the urgent necessity to reveal all aspects of reality. These photographers deconstruct existing reality, rather than attempting to construct a new and improved, but essentially false, version of reality.

In the 1920s photographers used oblique viewpoints and

enlarged or telescopic views to suggest upward movement, and thereby convey a sense of optimism. Nowadays, though, these same techniques push people to the sides of the picture, expressing feelings of isolation and desolation. By the same token, methods once criticized as formalist for focusing not on man but on lines and graphic patterns have been given a human touch, and often concentrate on man in an almost affectionate way. Unlike their revolutionary predecessors, who wanted to break with history, contemporary photographers bring an awareness of all stages of the Soviet past, including their own social roots, to their work. They use stylistic elements and subjects prevalent in the 1920s and 1930s, yet do so with a new sense of irony and distance in order to enhance awareness of the world of images that has governed Soviet reality since that time.

What about the Soviet public who, for the first time, is seeing pictures so different from the easily digestible images they had previously been shown? One should not underestimate the influence of Socialist Realist images on the way people have regarded the world. It is easy to imagine how difficult and painful it must be for individuals to break with familiar and comforting codes of representation—to be deprived of a seamless image of a flawless and beautiful world free of all deficiencies and weaknesses.

Under Stalin, Socialist Realist photography adopted a powerful and reassuring symbolic language. Recent Soviet photography challenges and rejects the static, monumental nature of those images; in this new work, the appearances of everyday life are presented openly, not suppressed for ideological reasons. At this point, though, it is impossible to say whether the Soviet people will come to accept the new photography as part of a new whole. That will depend on the economic and political changes that perestroika brings about, the possibilities it offers for achieving radical changes in everyday life. This, however, is a question that will be answered not by aesthetics, but by politics.

1. S. Fridlyand, "Za proletarskuyu fotografiyu," *Sovetskoye foto*, No. 1, September 1931, p. 14.
2. A. Rodchenko, "Predosterezheniye" (Warning), *Novyi lef*, No. 11, 1928, p. 37.
3. A. Rodchenko, "Krupnaya bezgramotnost' ili melkaya gadost'?", Open letter to the editor of *Sovetskoye foto* published in *Novyi lef*, No. 6, 1928.
4. A. Rodchenko, "Puti sovremennoy fotografii" (Pathways of Contemporary Photography), *Novyi lef*, No. 9, p. 32.

Herkki-Erich Merila, *Tallinn Burning*, 1988

Boris Savelev's "Photocartochi"

"My impressions of life are expressed in snapshots of towns," Boris Savelev has written, adding: "I believe that one can get the best idea of the life of a person from his environment and the objects that surround him." Savelev's work in the streets of Moscow and Leningrad offers insights both into his art and into contemporary Russian society. As Lisette Model, one of the medium's greatest teachers, once said of the snapshot, "Of all photographic images it comes closest to truth."

In the West, it was Robert Frank's breakthrough masterpiece of the 1950's, *The Americans*, that awakened viewers to the often-disturbing truth of "informal" image-making. Savelev's photography offers a similarly probing view into the strangely muted world of color that is the milieu of urban Russia.

Born in the Ukraine in 1948, Savelev attended the Aviation Institute but abandoned his engineering career in 1982 to work as a free-lance photographer. He first gained international recognition with black-and-white images published in *Another Russia*, which were subsequently exhibited in Europe and North America. Throughout most of the 1980s, his color transparencies were taken out of the Soviet Union and processed in the West. Savelev kept his prints out of view, piled up in a small Moscow suburban home that he shares with photographer Elena Darikovich. With the ideological thaw, the color images became the subject of a new book, *Secret City: Photographs from the USSR*, published by Thames and Hudson in 1988.

Savelev's intent, as he puts it, is " 'polyphonic' for I pursue the possibilities combining unexpected events to produce numerous levels of meaning, following the tradition of Atget, Evans, Rodchenko, and Friedlander." He also calls his photographs *photocartochi*, or postcards. Again, he strikes a sympathetic note with Western artists. It was Evans who once praised the postcard field as "rich in realism, sentiment, comedy, fantasy, and minor historical document." Savelev is a sophisticated virtuoso of the snapshot and its grasp of the specific spiritual moment.

Boris Savelev, from the series "Town," 1981–1985

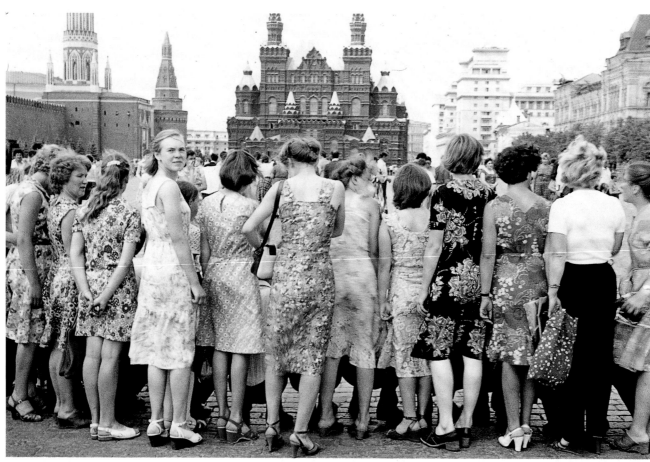

Many Nations, Many Voices

By Daniela Mrazkova

What is Soviet photography? The term is purely geographical: a convenient name for all photographs produced in the fifteen unions and twenty autonomous republics of the Soviet Union, whose rights to self-determination as individual nations were disregarded by Stalin's expansionist policies. The Baltic republics—Lithuania, Latvia, and Estonia—differ widely from each other both historically and culturally, and yet all three have played key roles in the postwar development of photography in the U.S.S.R.

Aleksandras Macijauskas, from the series "Village Markets," 1972–1988

Since the 1950s, the Baltic nations have rebounded from Stalinist oppression to revive their culture. Taking pride in their own national traditions, many people in these republics are now clamoring for their right to self-determination. Photography, because of its ability as a documentary medium, has become one of the most powerful tools available in this struggle for national self-awareness. Just as Lithuanians, Latvians, and Estonians once turned to singing popular folksongs to manifest the vitality of their national traditions, they now use the camera in an equally expressive way.

The largely pastoral images produced by Baltic photographers have served as a corrective to the picture of life that has long been disseminated in official propaganda throughout the U.S.S.R. Photographs of traditional Baltic folk customs, or of country life and pastimes, contrast in their simple humanness with the seemingly endless numbers of photographs of heroic ballet-dancers, athletes, collective farmers, workers, cosmonauts, and soldiers that have long dominated official imagery.

Infused with strong national feeling, Baltic photography was for many years unacknowledged in Soviet exhibitions and the press. It was not until the end of the Brezhnev era that cultural officials began to lose their deep mistrust and ignorance of the photography being made in the region. Yet even during those years of official ostracism, those involved in the Baltic photography movement became so active and played such an important social role that they realized the need for an organizational base to further their concerns.

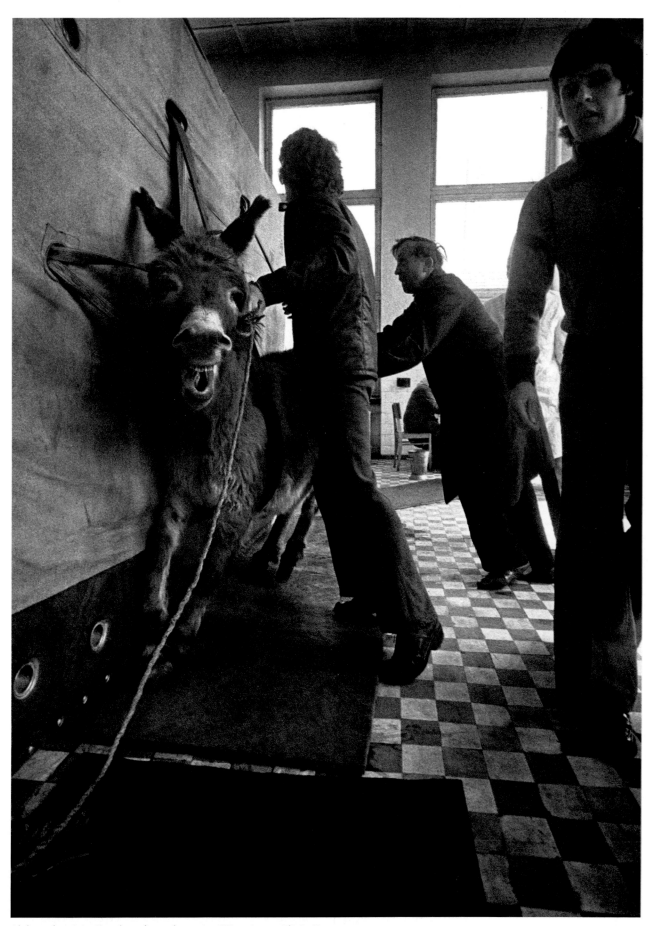

Aleksandras Macijauskas, from the series "Veterinary Clinic," 1978–1988

Aleksandras Macijauskas, from the series "Village Markets," 1973

Aleksandras Macijauskas, from the series "Village Markets," 1975

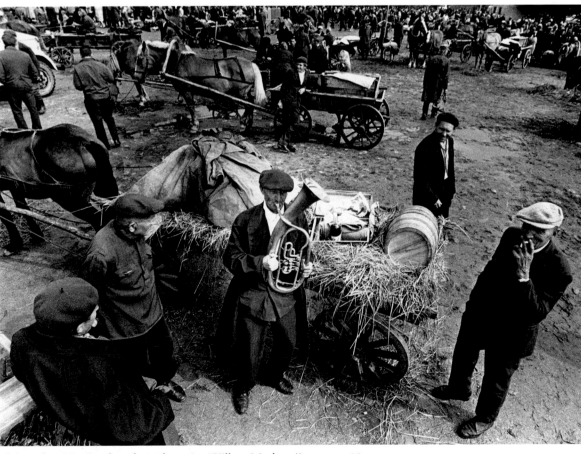

Aleksandras Macijauskas, from the series "Village Markets," 1972–1988

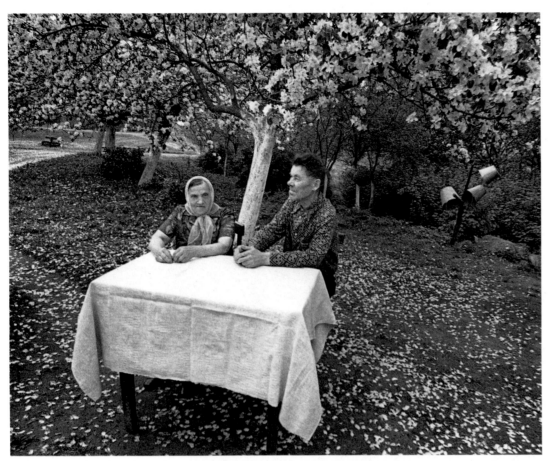

Romualdas Rakauskas, from the series "Blossoming," 1976–1985

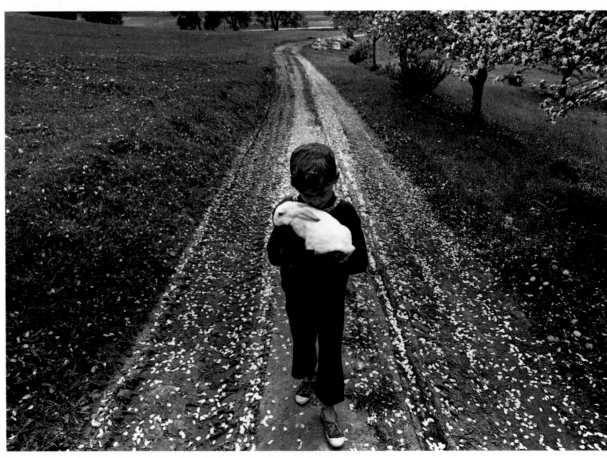

Romualdas Rakauskas, from the series "Blossoming," 1976–1985

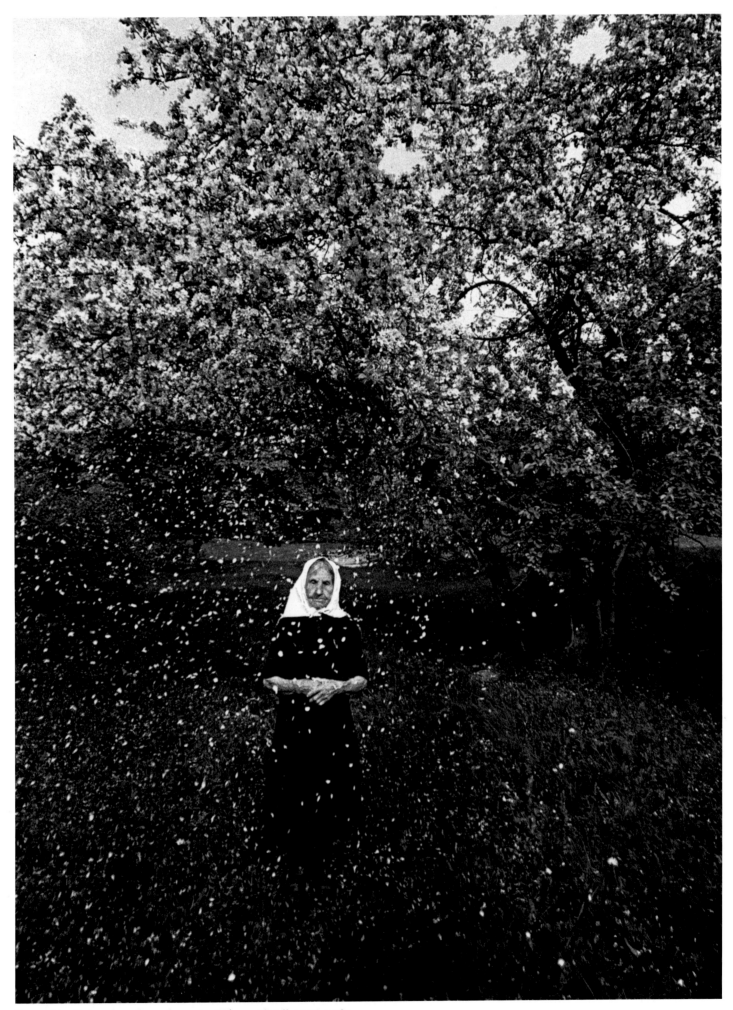

Romualdas Rakauskas, from the series "Blossoming," 1976–1985

As a result, in 1969 a group of photographers and critics founded the Society for Creative Photography of the Lithuanian Soviet Socialist Republic (L.S.S.R.). The society's founding document was signed by the Central Committee of the Communist Party of the L.S.S.R., which at that time was an unprecedented development. Until then no such organization had been permitted unless it had a structure analogous to that of similar organizations approved by the central government. This bold departure set the stage for a host of new regional photographic organizations and activities that operated under the auspices of the party and the government of the republic: exhibition halls and galleries, seminars and festivals, catalogues, books, and scholarships. The town of Shyaulyay opened its gates to a major photographic collection and a new museum. The Society for Creative Photography provided publicity and advertising services as well, and extended its help to amateur photographers struggling to become professionals.

While unified in a creative movement, the photographers in the Baltic republics have maintained very distinctive photographic styles. In Lithuania, for example, photographers have embraced two divergent trends, romanticism and realism. The romantics, led by the founder of the Society, Antanas Sutkus, take an optimistic view of the nation's past and present, although their pictures do evince traces of a bitter nostalgia. The realists, on the other hand, following the example of Aleksandras Macijauskas, express a rough view of reality seasoned with a free and easy, almost bitingly ironic spirit related to that of the writings of Nikolai Gogol. This can be seen in Macijauskas's own tragicomic images, in which country fairs are presented as open-air theaters where the dramas of life are played out. Macijauskas's photography offers a symbolic expression of the situation of the individual in the Soviet Union today, who must struggle to achieve a personal identity in a new world fraught with deep conflicts.

The recent work of these and other photographers, not only in the Baltic republics but throughout the U.S.S.R., expresses a great deal about the radically changed circumstances of Soviet society today. In its ability to combine and shift meanings and to express absurdity, irony, and other emotions, the new photography incorporates many attitudes taken by the Soviet people over the past two decades. In recent years a group of Soviet photographers has pursued a provocative and confrontational style which they mockingly call "soc-art." This new form of expression offers a fierce polemical attack on Socialist Realism, which was for many years the only artistic style officially acknowledged and condoned. Soc-art, as practiced by Boris Mikhailov, Roman Pyatkov, Alexandr Lapin, Boris Savelev, Alexandr Slyusarev, and others, uses the familiar elements of Socialist Realism in an ironic way, revealing its pompousness and pretensions to sincerity. Deliberately relying on less-than-perfect technical quality and the use of glaring, aniline colors, Soc-artists stress artificiality and superficiality as a way of underscoring the intense contradictions in offical Soviet society.

Long before the world learned how to pronounce the words "perestroika" and "glasnost," Soviet photography had begun to record the changing climate of a multinational society with the accuracy of a seismograph. In doing so, it harked back to the raw truth presented in Soviet photographs from the tumultuous epochs of the Revolution and World War II. If, as Vladimir Mayakovski wrote, "real poetry must be ahead of life by at least an hour," then recent photography—expressing the diverse national cultures that make up the Soviet Union as well as the new circumstances common to Soviet culture as a whole—has outstepped social reality by many years.

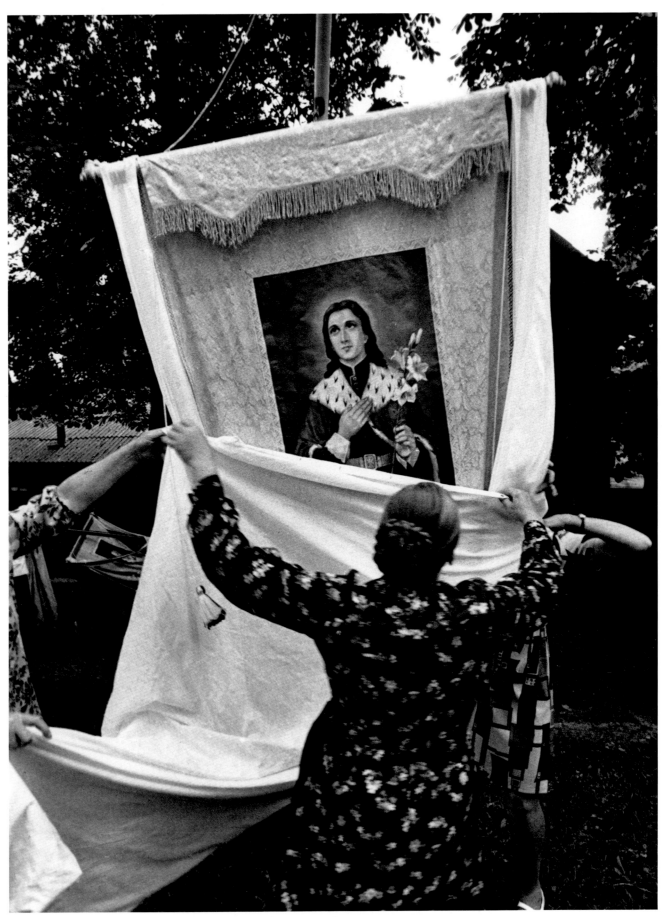

Romualdas Pozerskis, from the series "Country Celebrations—Pilgrims," 1980–89

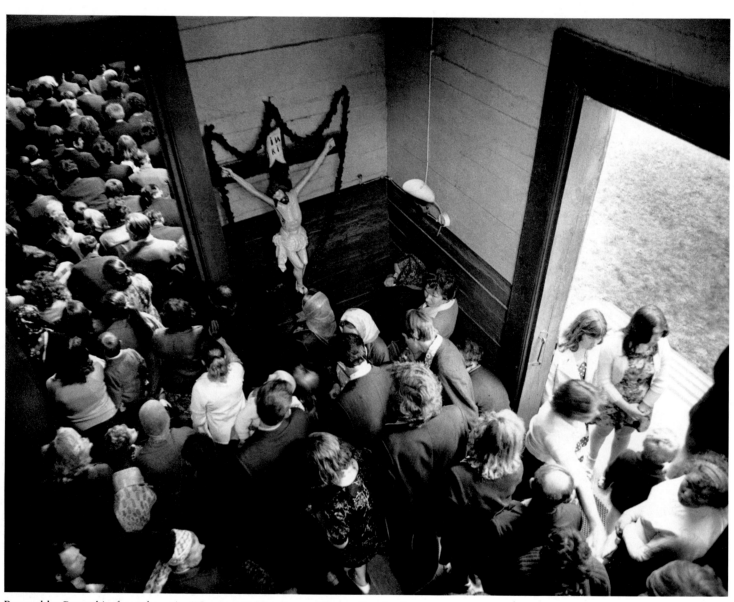

Romualdas Pozerskis, from the series "Country Celebrations—Pilgrims," 1980–89

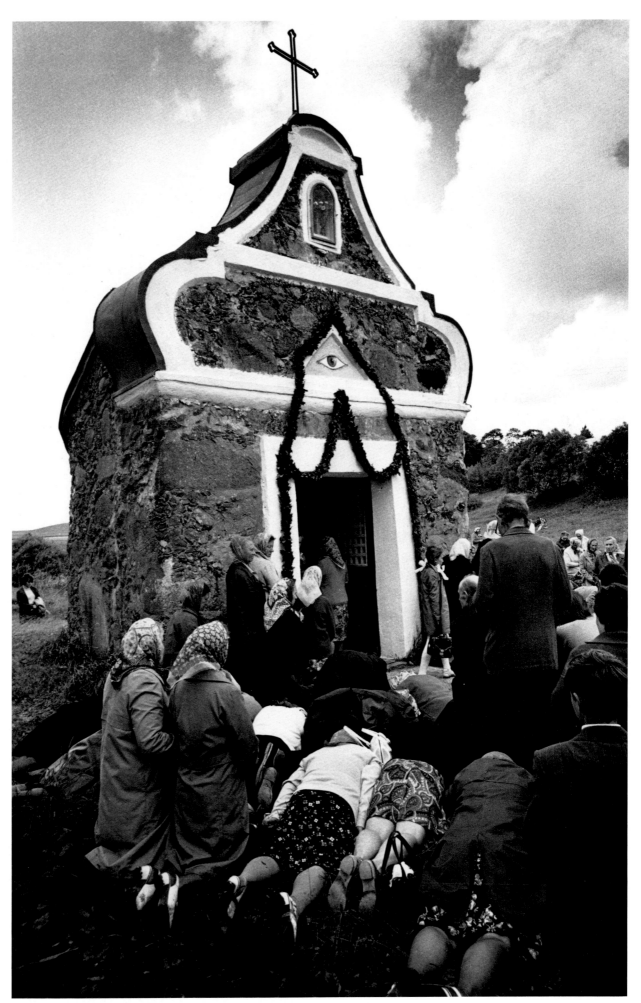

Romualdas Pozerskis, from the series "Country Celebrations—Pilgrims," 1980–89

Lyalya Kuznetsova's Scenes
of Gypsy Life

By Inge Morath

A little more than a year ago I had a show of my photographs in Moscow. A few days after the opening, my interpreter, Svetlana Makurenkova, told me that several photographers wanted to meet me and show me their work in a studio that belonged to one of them.

The studio was in one of those Moscow neighborhoods where tradesmen and artisans seem to live in houses with peeling paint. Entrances lead to multifamily flats through courtyards and over dark and narrow stairs—part of an older Moscow that I like.

There seemed to be no professional jealousy among the photographers. Their main complaint was their forced lack of communication with the West: they wanted to get their pictures out there to be seen and published. As travel abroad is still very restricted—except to other socialist countries—there was a profound feeling of "Russian-ness." Their individual styles were different, but not as diversified as they might be in this kind of group in New York. They were also less imitative, with a refreshing absence of trendiness.

Toward the end of our little meeting, as nuts and dried fruit, cookies, tea, and a bottle of Russian champagne miraculously appeared, they brought out a final envelope containing the work of Lyalya Kuznetsova, a photographer who lives in Kazan and could not come to the meeting in Moscow.

I was taken with her photographs at once. There is a rare combination of seeing and feeling in these pictures, an inner understanding and a lack of sentimentality. Lyalya seems to be drawn to the more vulnerable members of human society, to those whose strength does not reside in force but in the creation of a magic of their own. There are pictures of circus performers leading their very own lives. There are images of gypsies, not posing but free, who let her get close and watch them in their own space just as birds let you watch them as long as you do not disturb their ways. And there is a wonderful series of photographs of women observed as they were getting ready for all kinds of things important to their lives: beauty contests, performances, a date.

Lyalya's touch is light, but it is decisive. She is a poet who knows her craft. She is not afraid to reveal weaknesses or vanities, little frailties or idiosyncrasies, but she reveals them with sympathy, occasionally with tenderness. Her images linger in the mind like some special memories of one's own.

On my next visit to Moscow and the studio of my photographer friends I met Lyalya herself. She was just as I had imagined her from seeing her work: graceful, with a lovely face that knows tears as well as laughter. And there was no doubt about her strength of will to get the work she considers important done and seen.

Lyalya Kuznetsova, from the series "Gypsy Life," 1979–1988

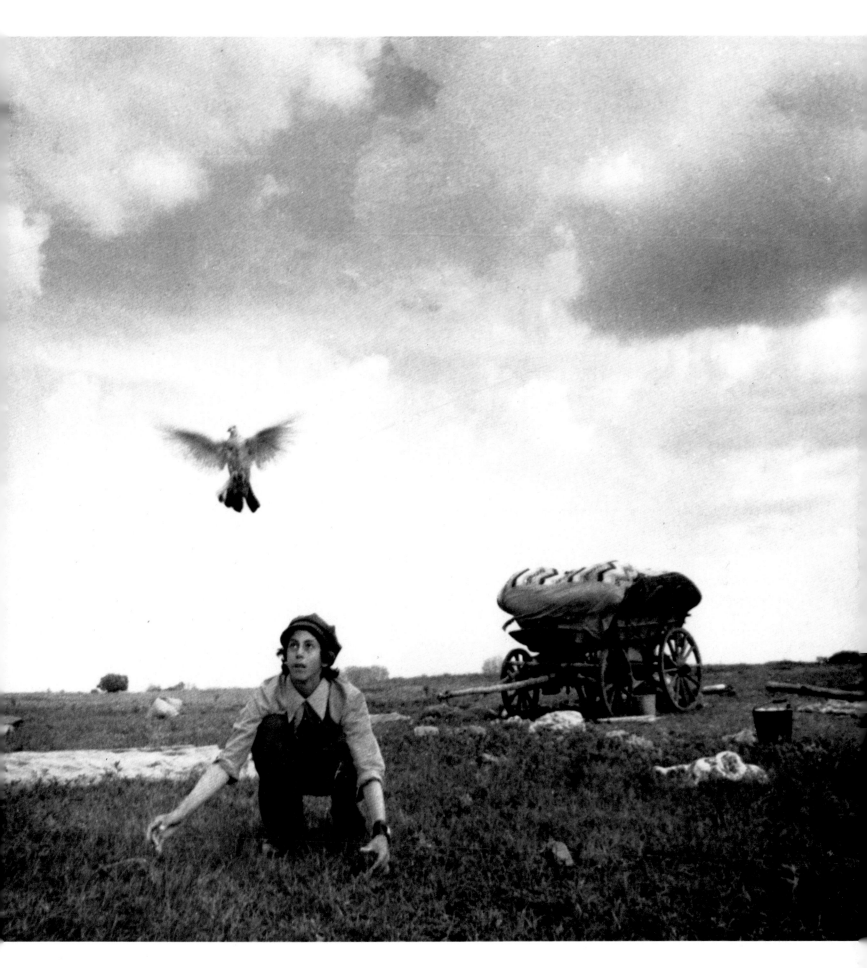

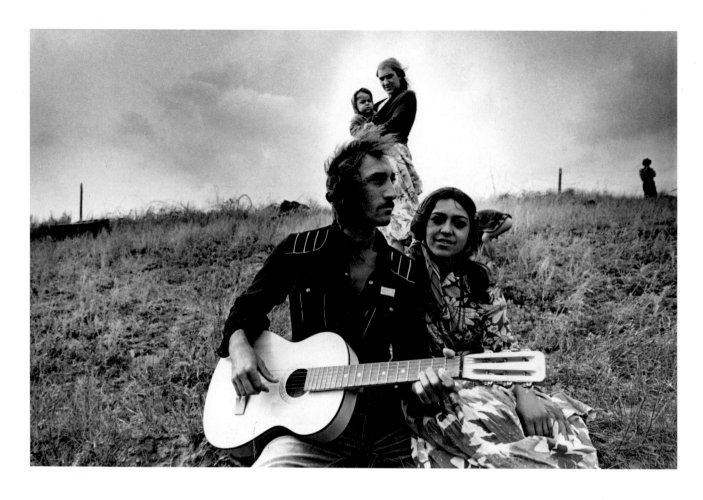

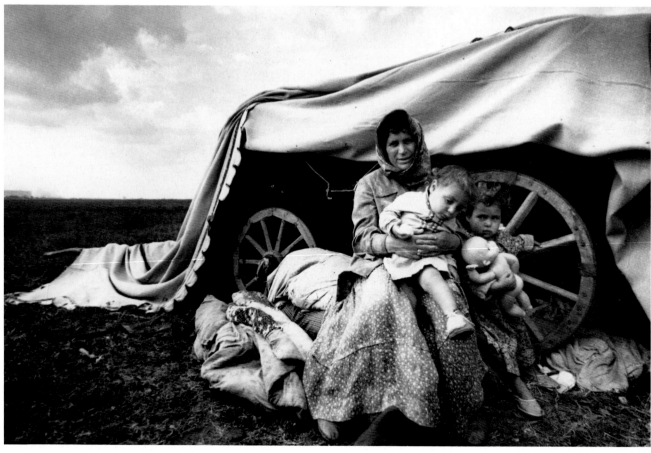

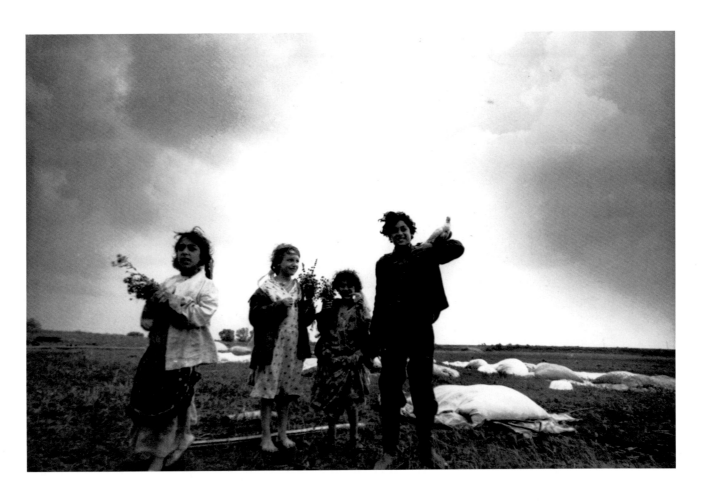

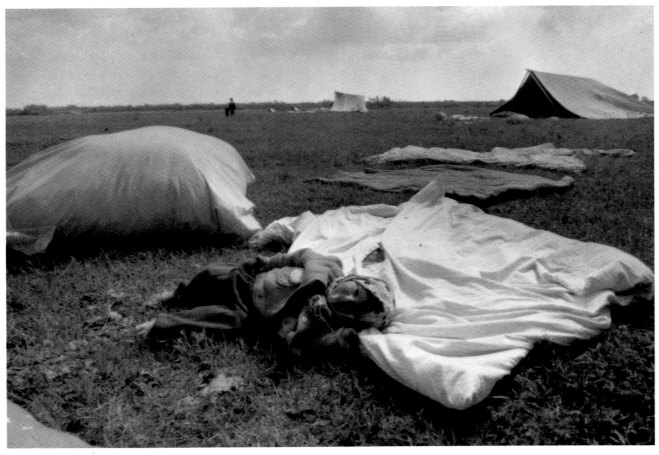

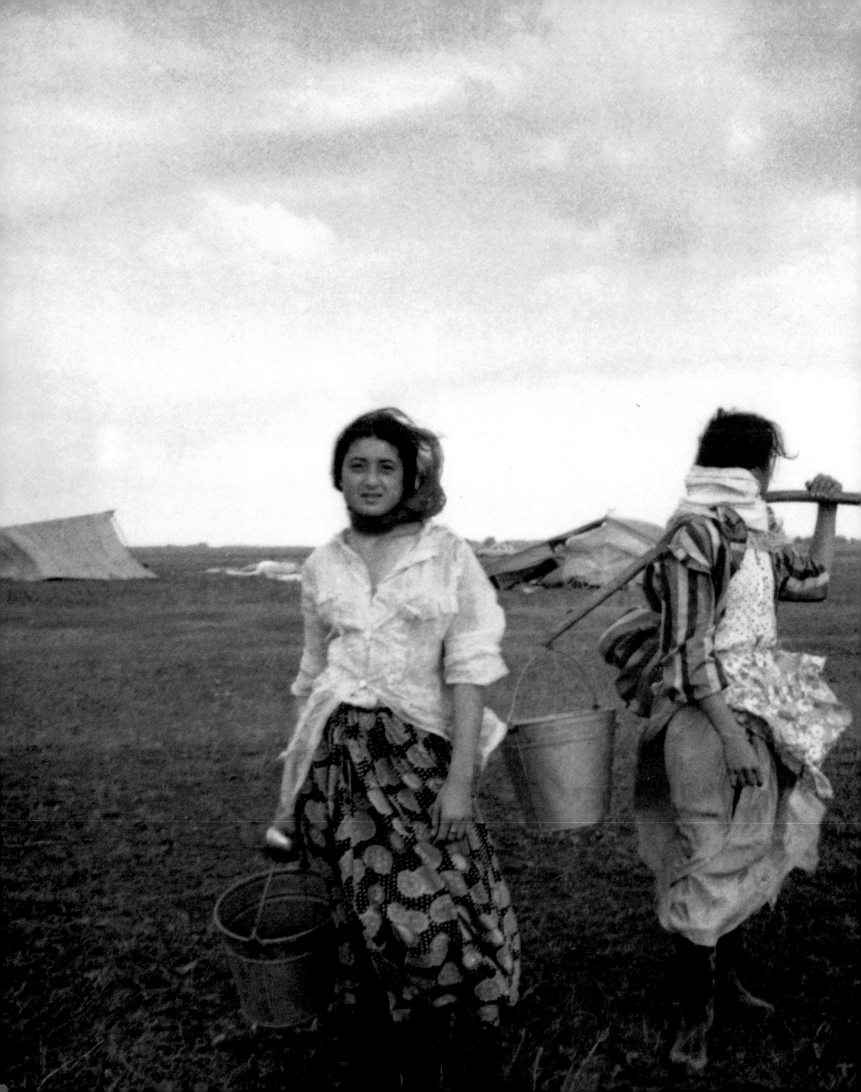

The Perestroika of Memory

by Olga Carlisle

After more than seventy years, Soviet citizens are permitted to remember. Under glasnost, each individual has gained the right to a personal view of the past. At the same time, the easing of censorship is providing an ever-widening knowledge of that past. The revelations of repression, terror, and rapacity are shattering, but the repudiation of Stalinism is breathtakingly rapid and far-reaching and may well be irreversible. Inconceivable only a few years ago, the words of the new head of the KGB announce a sustained change for the better: "Previously it happened that state interests had priority over civilian needs. This is no longer possible." The Party's self-serving power to invent and re-invent history has abruptly ended.

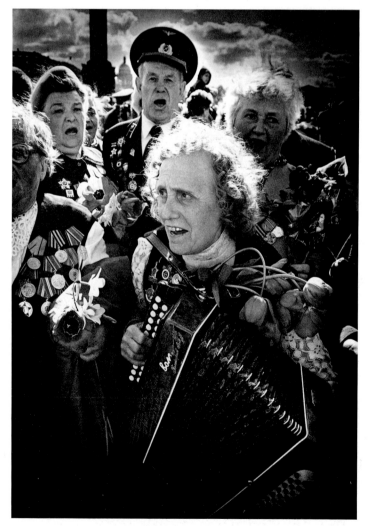

A. Nikolaeva, *Untitled*, 1988

But with the right to remember comes a sense of moral responsibility. It is no longer possible blindly to accept the state's view of things. It appears that ethical choices were important all along, that an individual's truth is of supreme significance.

However obliquely, the photographs assembled here address themselves to this new consciousness, one shared by the various Soviet nationalities, all of which in the past had to conform to the same rigid ideological mold. Nature, a privileged subject of artistic celebration (portrayed, for example, in color photographs made by my grandfather, the writer Leonid Andreyev, before the Revolution), is all but absent here, as are manifestations of collective rejoicing, once a favorite theme in Soviet art. The images are bleak, even sorrowful, sometimes marked by bitter irony.

Boris Mikhailov's photographs of war veterans and of folk artists are among the most ironic. They speak of the isolation of the individual within the crowd. The man with the cello is not looking around for culprits to blame for his plight, his expression is one of vague bewilderment, as if he had just awakened from a dream: "What has happened to me?" he seems to be asking.

Longing for the past pervades Vitas Luckas's and Natalya Chekhomskaya's constructions. In subtler form it is also present in Toomas Kalve's and Rein Kotov's works. We are reminded of Tarkovsky's more enigmatic images, from *The Mirror* and *Nostalgia*, in which troubled, half-repressed memories struggle to reappear, yet never fully do. They fill us with a nostalgia tinged with guilt.

To recall the past, to understand it, to grieve might alleviate the sense of loss, but this cannot be in a society which has falsified its history. Artistic illumination eludes us. Looking at these pictures we are reminded that, no matter how coercive that society had been, everyone within it has to find a way to preserve and nurture memories. We must remember in order to be able to forgive and to see life around us with fresh eyes. Fear and estrangement are the price paid for evasions. If the disasters—human and ecological—are irreparable we will still have to remember. In the words of the poet Osip Mandelstam, who died an anonymous death in a concentration camp somewhere in Siberia in 1938,

We will remember, when Lethe is frozen,
that life to us was worth ten heavens.

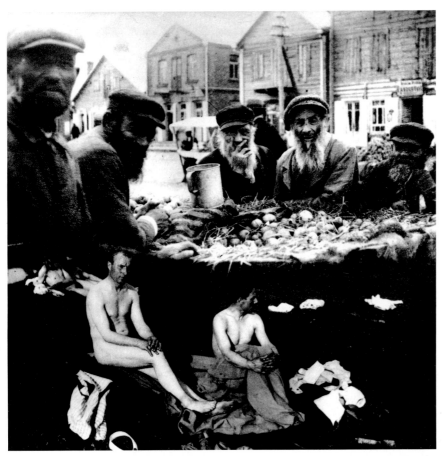

Vitas Luckas, *Sunday,* 1979, from the series
"Approach to Old Photography," 1979–87

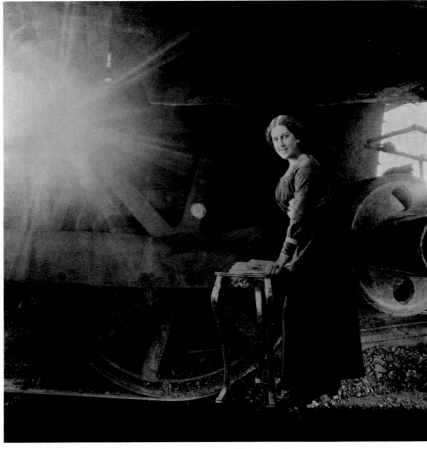

Natalya Chekhomskaya, from the series "Family Elegy," 1988

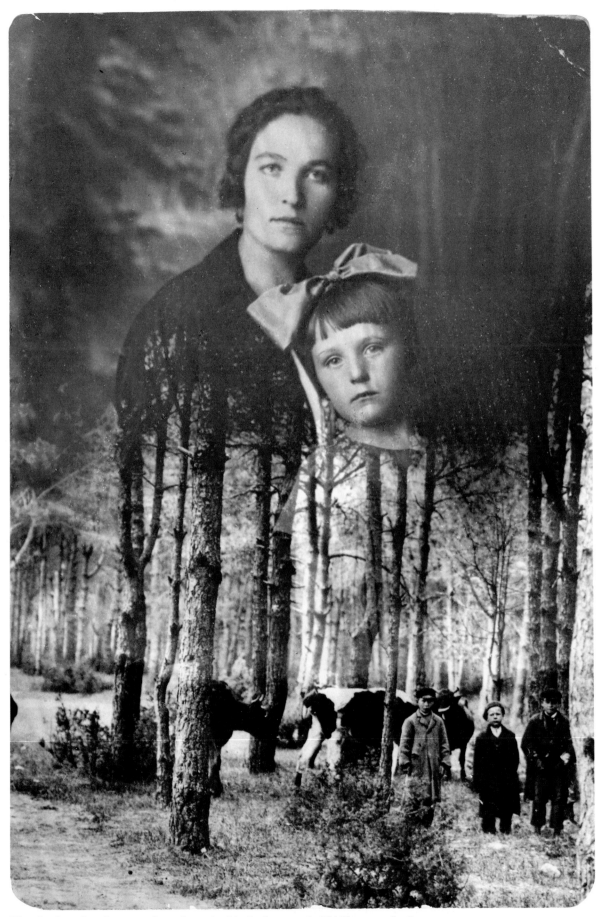

Vitas Luckas, *Past Summers* from the series "Attitude towards Old Photography," 1979–1987

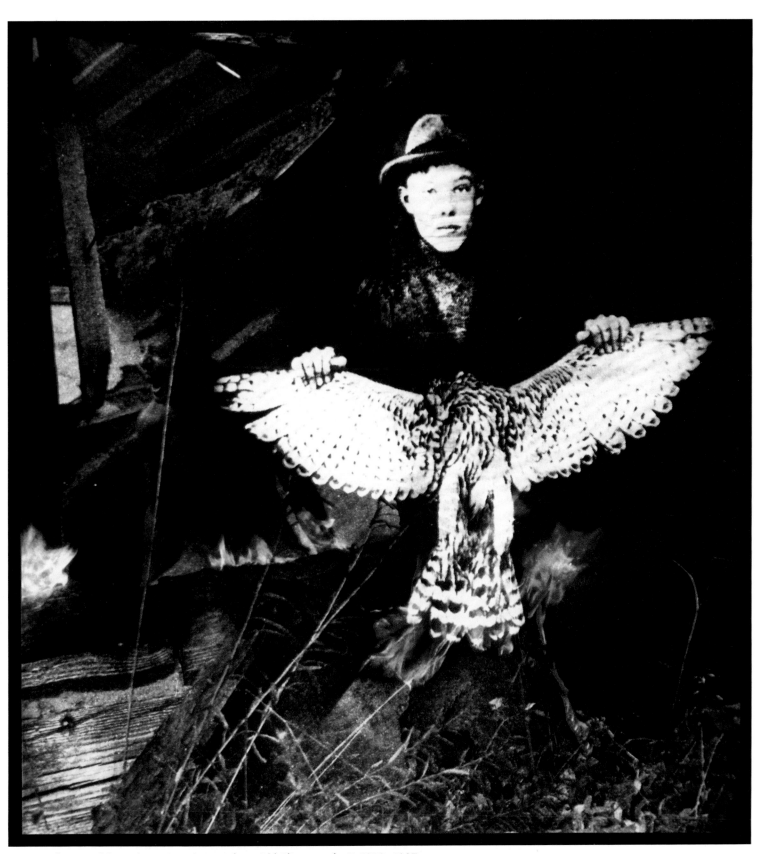

Vitas Luckas, *Bird* from the series "Approach to Old Photography," 1979–1987

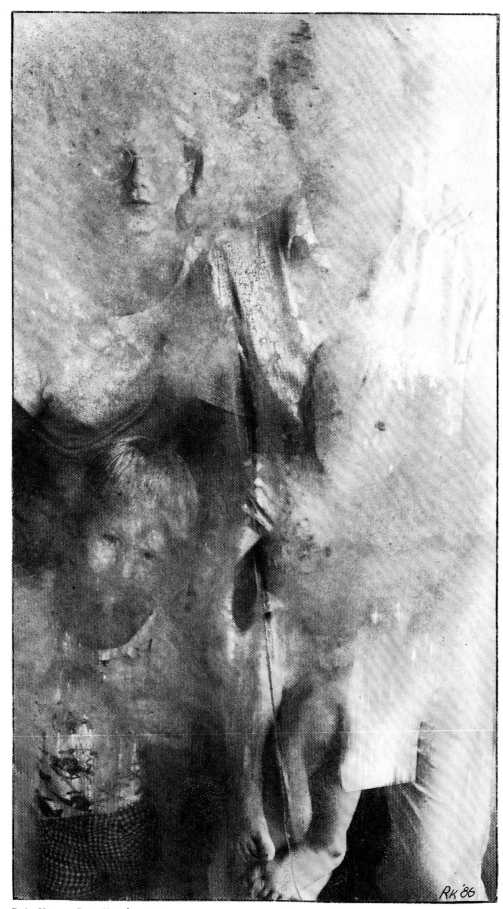

Rein Kotov, *Pere Kond*, 1986

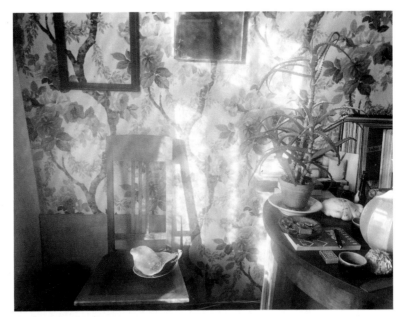

Toomas Kalve, *Interior*, 1988

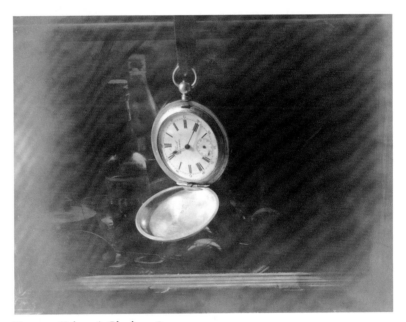

Toomas Kalve, *A Clock*, 1989

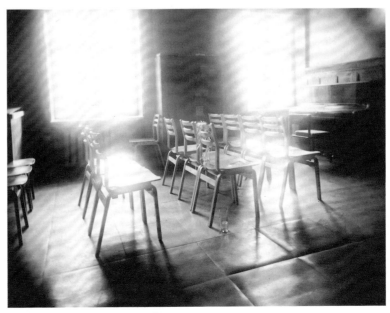

Toomas Kalve, *Studio*, 1989

The Nude Unbound

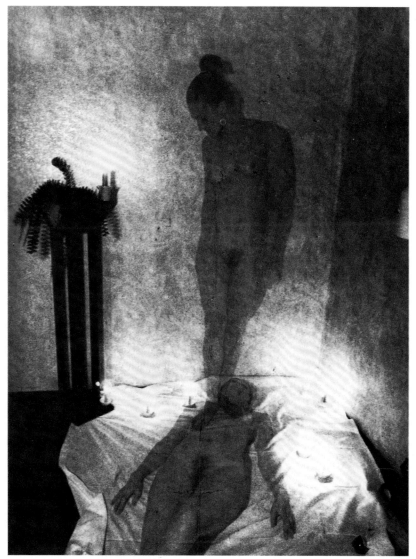

Toomas Kaasik, *Night Dream*, 1989

The nude as orthodox expression of social realism was an international impulse in the 1930s. Witness Thomas Hart Benton's murals, Paul Manship's heroic reliefs in Rockefeller Center, or even Dorothea Lange's field hands—all homage to the heroism of the common man. But art in the West moved on to Henry Moore's nudes, to Willem de Kooning's women, and to the unsettling imagery of Joel-Peter Witkin, Lucas Samaras, and Robert Mapplethorpe.

By contrast, the aesthetic of the nude in the Soviet Union remained immobile, stonelike. The protean genius Rodchenko perhaps created the epoch-freezing photograph, *Tower of Men*, 1935: a score of brawny young athletes shouldering a tower of discs as a pedestal for a triumphant goddess of Socialism. For half a century—until the advent of glasnost iconoclasts—the nude was neither naked nor particularly expressive. It was an archetype of the ideal, shrouded in orthodoxy.

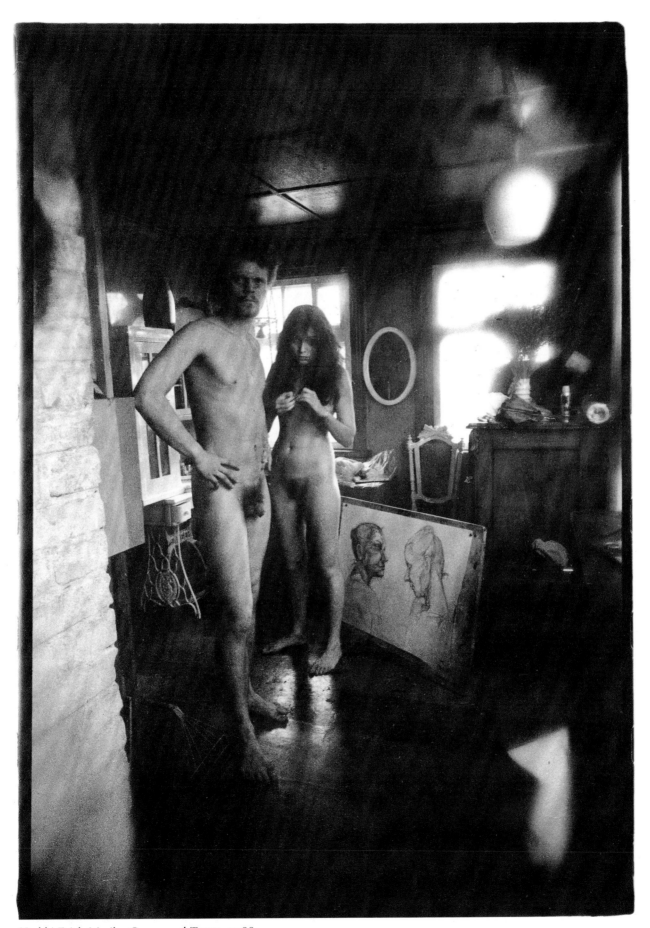

Herkki-Erich Merila, *Communal Tango*, 1988

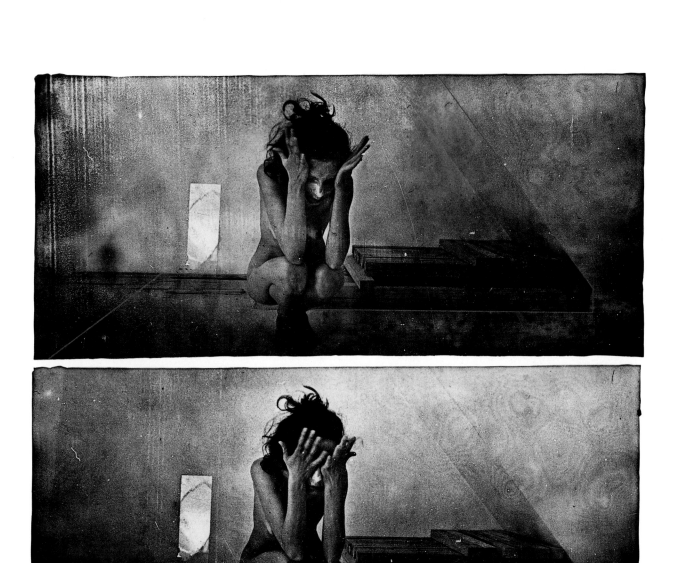

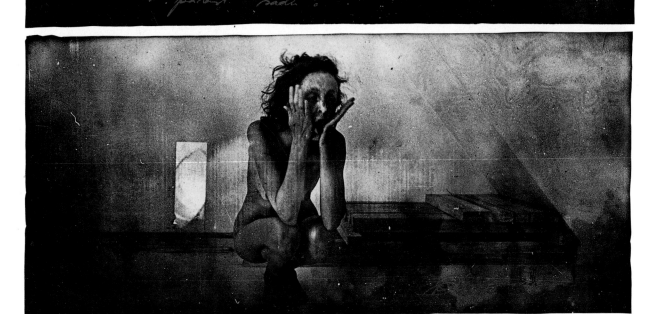

Peeter Laurits, *The Last Drop of the Shower*, 1988

48

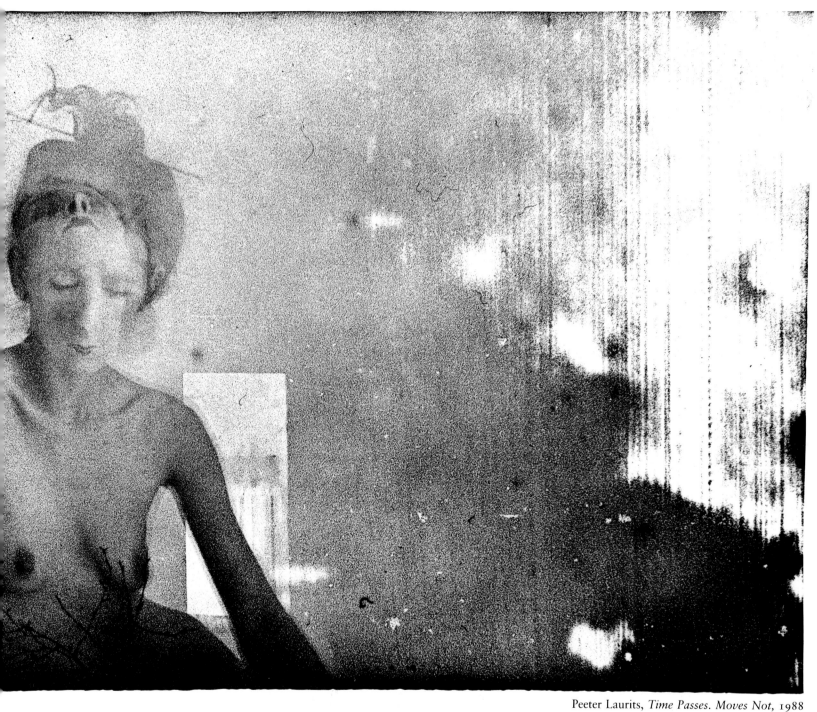

Peeter Laurits, *Time Passes. Moves Not,* 1988

"Naked truth" (Russian equivalent, curiously, *chistaya pravda* or "clean truth") is a truthless but suggestive cliché as applied to nude photography. A naked face may assume many masks, but the body's disguises depend more upon the camera. Is the event erotic, or only the image of eroticism? The boundary between such fact and fiction is desperately misunderstood by proletarian moralists in the West. The coming of *photostroika* brings this confusion to the proletarian ideologists of the East.

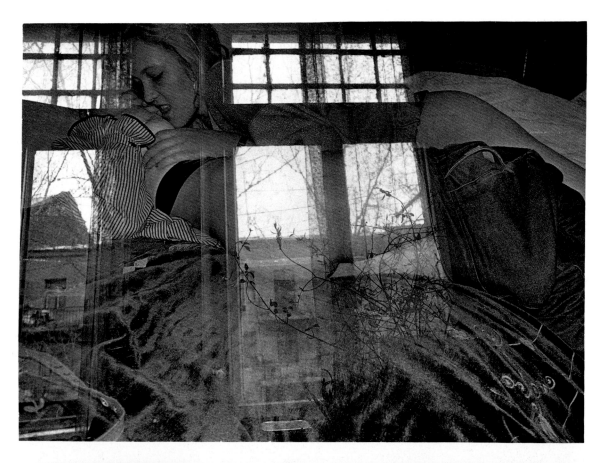

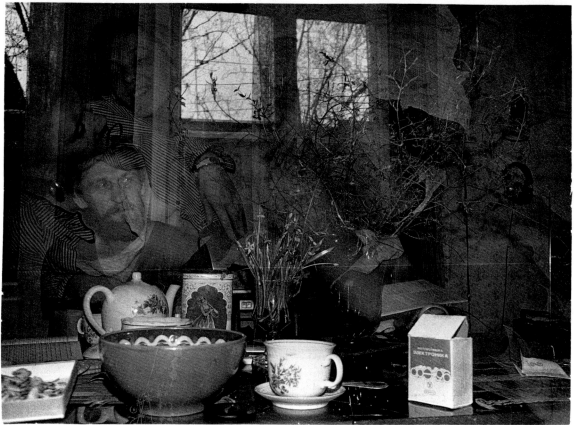

Roman Pyatkov, *Love in the Kitchen*, 1988

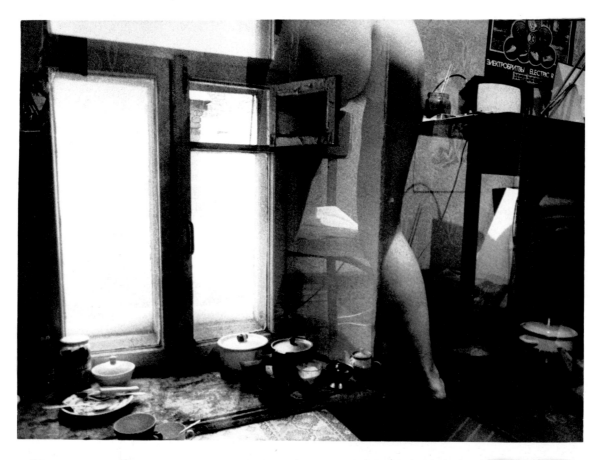

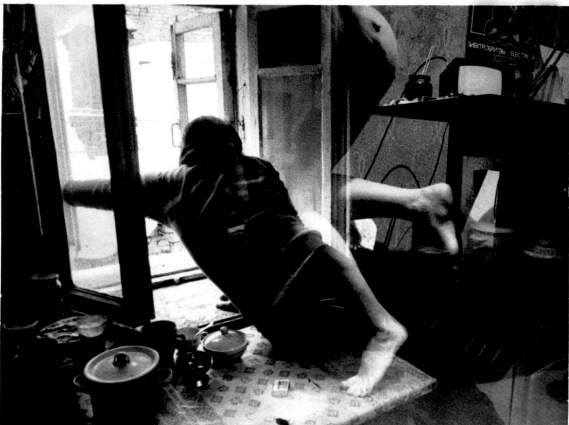

Roman Pyatkov, *Open the Window, I'm Leaving . . .* , 1988

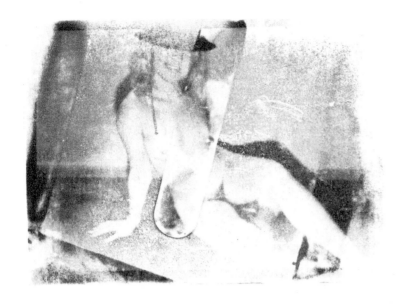

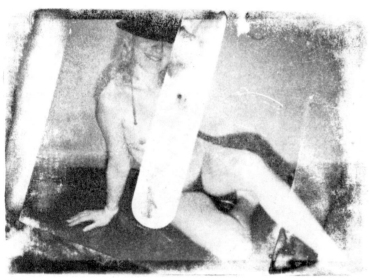

Tonu Valge, *Untitled,* 1988

As the nude studies of a new generation of Soviet photographers become available—so newly available, in convenient fact, that none of their captions is dated pre-glasnost—an artistic dialectic emerges. The wretched, suffering pre-Revolutionary forms evoked from the imagination by Gogol's *Dead Souls* confront their antithesis in Rodchenko's socialist demigods. As synthesis, the nude, reflective of the Soviet Union itself, enters a post-heroic age. Ideology gives way—at least for a time—to the vulnerability, richness, and mystery of this most meaningful of forms.

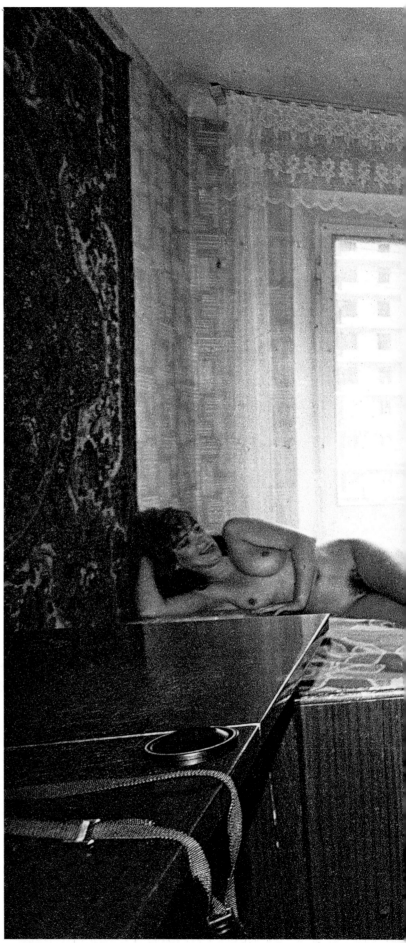

Roman Pyatkov, *Witches' Sabbath,* 1988

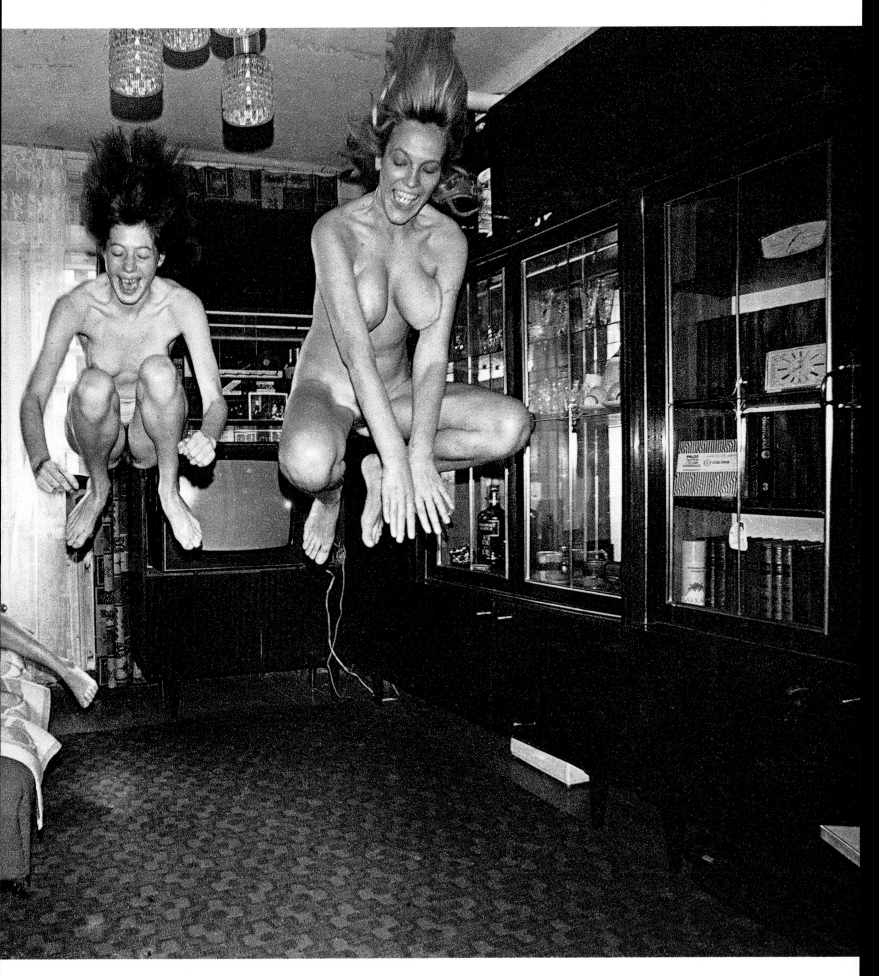

Dark Light

by Peeter Linnap

Peeter Linnap, from the series "Night Landscapes," 1987

I took the series "Night Landscapes" in the autumn of 1987. I don't myself know why I chose to use the old German Praktica camera together with the 20 mm. wide-angle lens and to shoot only at night, in pitch dark, with a flash. To me, the light of the flash is part and parcel of photography. It gives the surrounding objects a new form of existence and breaks down the everyday, logical spatial relations into separate fragments. In this way I was able to get rid of sensual perception and managed, with considerable ease, to find visual counterparts for my inner intuition.

The flash has quite an interesting parallel in the process of perception. Now and then some unknown images rush by in my mind coming from God knows where, whimsical pictures from memory, lacking space and time. These imaginary pictures last but a moment. Nevertheless they remain long enough to allow me to come to a kind of subconscious recognition in the mythogenic deeps of my mind. It seems we manage in this way to feel the touch and breath of Eternity.

I recall having experienced similar visions in early childhood—but even then they seemed to belong to a very remote past.

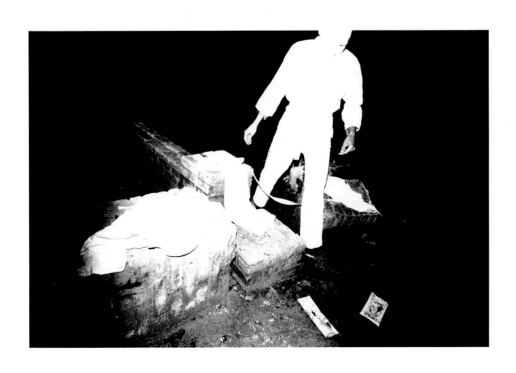

Up from Underground

By Hannu Eerikainen

Two opposing trends coexist in Soviet visual culture: idolatry and iconoclasm. The adulation and destruction of images has dominated Soviet official photography since the early days of the state, and has created a visual environment of approved images, while at the same time there are gaps because of forbidden images.

Those who hold power have always recognized the magical force of photography. How else can we explain, in societies where the state controls cultural life, the proliferation of cult portraits of leaders, the eradication of photographs of unpersons, the explosion of propaganda, or the declaring of numerous photographic subjects taboo? The role pictures play in Soviet society has long been controlled by a Byzantine thought structure in which photographs are seen as instruments of power. Pictures serve the state, the rulers, official doctrine, the established order. Their ritualistic use reflects the hierarchy of authority. Both form and content are regulated by convention, and the photographer is seen as an anonymous craftsman, watched over by an omniscient legion of priests, whose images are meant to reflect the views of the orthodox, not those of ordinary people.

Against this background a new kind of Soviet photography takes as its central attributes the private, the personal, and the intimate. These pictures serve no governmental authority and refuse to carry the burden of dogma. Instead they express the views of their creators, offering the testimony of individual experience. This new trend is forcing a reinterpretation of the prevailing Soviet concept of photography. Even today, official photography consists of documentation, journalism, propaganda, and illustration. Ideology and politics continue to dominate its form and content. The new photographers criticize this tradition, and set out, instead, to make the relationship between picture and reality the fundamental question. They doubt the validity of simple representation, whether its goal is to imitate life or to convey a predigested message or moral. In the new photography the photographer plays a central role.

For decades, individuality has been regarded in the Soviet Union as a kind of deviance, the sign of an inability to adapt to socialism. Those familiar with Soviet publications or exhibitions cannot ignore the similarity of the pictures in them, which lends them a kind of anonymity. As images, these pictures are not intended to express individual life, but rather group experience. As a result, the creator of the image has disappeared. The new photography, though, insists on retaining the identity of the photographer, and sees photography as a manifestation of personality. Where postmodernism, in the West, questions the role of the individual photographer in making the work, in the Soviet Union these new picture-makers approach the question from the opposite perspective: the photographer as creator, and the expression of a subjective and original viewpoint, are most important.

This new photography emphasizes authenticity: the photographer's genuine interest in the life of his subject, in spontaneous situations, and in the quotidian world. The photographers emphasize that they do not seek ideological justification for what they see and experience. Each picture has an idiosyncratic point of departure, an immediate relationship to time and space. Through photography the artist defines that which exists while at the same time creating something which exists only in and as a photograph. This could be called the politics of experience.

A basic question posed by the new photography is what the essence of political experience is in the Soviet Union today. Is it disciplined masses marching under the party flag? Open discussion among people in the streets? Politics in the U.S.S.R. is a complex arena. People everywhere speak of declining values; Mikhail Gorbachev speaks of alienation and apathy. Politics has come to mean public mendacity; participation in politics has become equated with committing oneself to a lie. This has led to anxiety for everyone who still has a moral sense. In a closed and one-directional society, even the act of thinking is unavoidably political in nature. Independent thinkers engage in criticism, breaking down the dominant discourse in a "politics of language." This same sort of analysis is just what Soviet photographers are now attempting to do. The new photographers are not necessarily dissidents or *inakomyslyayushchie*, which literally means "people who have a different way of thinking about things." Dissidents, as they are generally seen in the Soviet Union, are unconditionally opposed to the entire society. They wage a personal struggle against a system which they experience as faulty and unfair. The new photographers, in contrast, might better be characterized by the word "subversive." Rather than repudiating the system, they question basic values. These image-makers could instead be called *inakovidishchie*—"people who have a different way of seeing." Soviet citizens who think and act subversively, in this sense, have lost their faith in prevailing values and confidence in official authority, but they are not completely critical. Instead, they are interested in what can be done despite the system's limitations. On the individual level they are attempting to construct new ways of living, new values, new identities.

Seeing things in a different way means reevaluating the uses

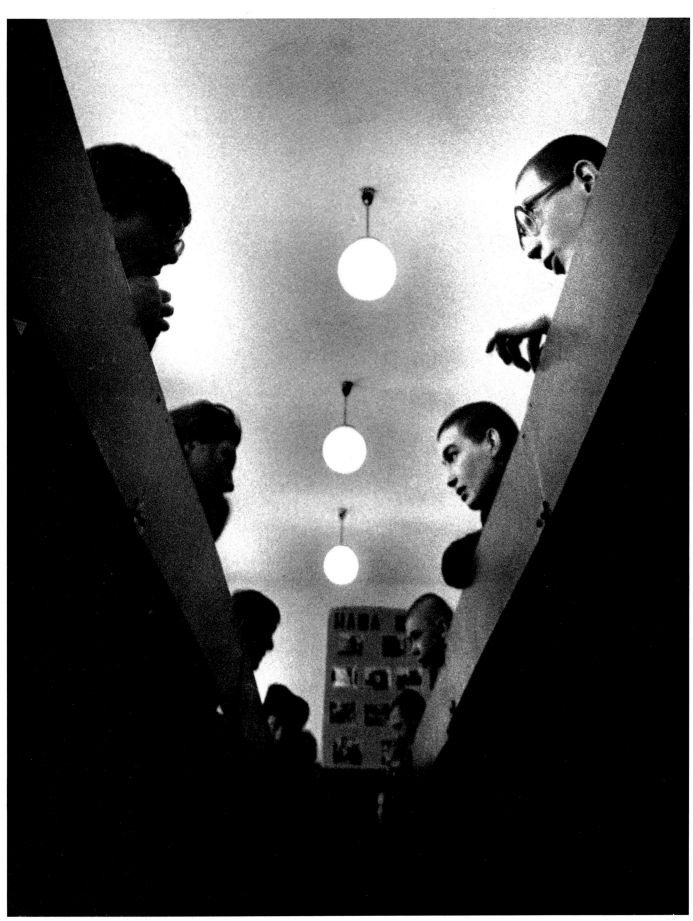

Igor Gavrilov, from the series "Young Prisoners," 1988

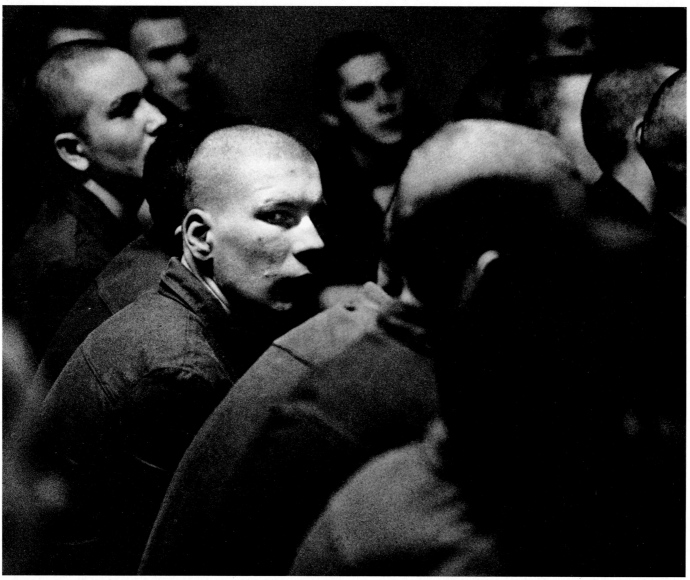

Igor Gavrilov, from the series "Young Prisoners," 1988

of photography. It also means reinterpreting the concept of the "photographic." In the Soviet Union, a photograph is still officially a record of fact, a document, a piece of evidence; in the opinion of the leaders it is a powerful tool in society, an instrument too effective to be left solely to photographers. The attitude of those in power toward photography is dominated by two truisms: first, that everything photographed is true and that everything true can and must be photographed; second, that photographs have an effect on the viewer which is direct, immediate, and unequivocal. These beliefs can be traced to the early years of the Soviet state. During the Stalinist era they assumed the force of dogma, the inviolability of which was fiercely guarded with decrees and prohibitions by officials in charge of propaganda and art. Later these ideas developed into an ideology of photography which might be described as the doctrine of the omnipotence of the image, in a word 'iconism'.

During the Brezhnev era this idea grew increasingly important. The worse things became in reality, the better they seemed to be in pictures. Using the image as a political tool, the ruling circles created a world of delusion in which the verisimilitude of the photograph lent a particular credibility to the version of reality promulgated by the leadership. The greater the economic and cultural stagnation of the Brezhnev era, the more dominant the world of illusion became. The intelligentsia began to refer to the imagery of continual success and happiness as *paradnost*, "parade-like splendor," and *pokashukha*, "pre-

Igor Gavrilov, from the series "Young Prisoners," 1988

Elena Darikovich, *Boris*, 1984

Elena Darikovich, *The Yard*, 1985

Elena Darikovich, *Moscow*, 1984

tentious ostentation." New Soviet photography has developed as a critical reaction to the omnipotence of the image deployed as the property of the state.

Recent Soviet photography is not fundamentally a product of glasnost, but the outgrowth of underground activities of the Brezhnev era. This period provided the Soviet Union with a vigorous counterculture, and free and critical photography developed in conjunction with it. Never a unified movement, it instead encompasses a wide variety of creators, approaches, and concepts of photography.

During the Brezhnev era, subversive photography provided a concrete means for grappling with reality in a utopian dream world. The advent of the Gorbachev era has meant a greater degree of freedom for photographers, but to this day the omnipotent image still dominates Soviet photography. In reaction to it, new photography continues its subversion, eroding the conventions connected with making, publishing, and viewing photographs. But these photographs often find it difficult to reach the public. Unlike other visual arts, especially painting, this kind of photography is not officially accepted, and continues to exist in a marginal zone. It may be understandable that subversive activity would receive no support from the authorities, but in the Soviet Union, free photography causes real uneasiness due to a deeply rooted suspicion of the photograph's potential uses.

The mass culture of the West requires that individuals initiate a sort of public ego, identifying with social trends and mastering the presentation of the self. In Soviet culture the relationship between public and private is different. Concrete everyday situations, not images, are the vehicles through which people perceive themselves. Despite the overwhelming presence of the state in Soviet society, or perhaps because of it, an area of genuine privacy can be found in human relationships.

In Soviet society, the visual environment of everyday life is dominated by idealized figures, proletarians and patriots, which are offered as examples of moral and ideological rectitude. Visual propaganda, including billboards, posters, flags, badges, slogans, and displays of pictures of workers surround Soviet people everywhere. And, since the idea of a copy, or repetition is an essential element of Soviet culture, variations of the same basic pictures are repeated again and again in different contexts. Portraits of Lenin and other *Leniniana* dominate the horizon. Views of the revolution parade through everyday life, mingling actual achievements and utopian visions.

Alongside this visual culture aimed at directly political ends, is a mass culture with broad dimensions. Images of everything from folk traditions to cosmonauts are displayed everywhere. Before Gorbachev, television was the central medium through which deluding political imagery, offered in many variations of

(*top*) Francisco Infante, from the series "Flashes of Distorted Space," 1986
(*middle*) Vyacheslav Koleichuk, *Homage to Magritte*, 1985
(*bottom*) Francisco Infante, from the series "Reflections," 1979–1980

Vyacheslav Koleichuk, *Hill*, 1986

the trivial and the banal, seeped into everyday life. This kind of "Soviet kitsch," with its mawkish idealizations of popular characters, is part of the *poshlost*, commonplace or trite, aspect of Soviet life. The reverse side of this idealized political world is *rastyapstvo*, or negligence, sloppiness, and indifference. This term refers to the dilapidated and ramshackle state of the Soviet reality, one consequence of which is the crude aspect of public behavior, the gruff rudeness that prevails generally in Soviet life.

This daily culture grows from a historical background profoundly different from that of the West. Western cultures are dominated by visual semiotics; Eastern culture, in contrast, relies on a semiotics of concealed meanings and referential relationships. The West displays things, exhibiting them in public so they can be viewed, while the East hides, conceals, covers. The West sees the eye as a central metaphor; the East, the word. Westerners orient themselves by looking; Easterners, by thinking. The East reveals a sense of the absurd and an ability to read between the lines. Moreover, beside the spiritual depth of the East, the West seems even more a culture of surface.

Instinctive precaution about expressing one's ideas freely has provided Soviet culture with a particular sensitivity to veiled references. In the context of Soviet history, the act of photo-graphing something previously forbidden takes on considerable significance for both photographer and viewer, with Soviet viewers able to see meanings in the pictures that may not be apparent to Westerners. In the West, sex, consumerism, and media-created reality shape visual culture. The link between images and everyday life becomes thinner, or is obscured by a host of intervening factors. Pictures become visual comments on other pictures, woven together in multicultural layers of references. Everything happens on the surface, where a process of absolution of the visual takes place.

In the Soviet Union, the stagnation and closed nature of society, secretiveness, apathy, and alienation, have all led to a situation in which the idea of revealing things is at the center of critical thinking. In photography this means that, as in the 1920s, the new photographers proclaim the "politics of the new eye" as a way to pierce holes in the delusions of *paradnost* and *pokashukha*. The photograph as a document is the basis of this new concept, which embraces conceptualism, magic realism, formalism, irony, and the absurd. In the eyes of the new photographers, the documentary pretensions of official Soviet photography are completely false, and the search for a new and valid form of expression continues.

Kalju Suur, *Tomorrow they'll even fill it with water*, 1988

Vladimir Zotov, *The Slogan*, 1987

Alexander Grek, *Party Pictures*, 1986

Alexander Grek, *Party Pictures*, 1986

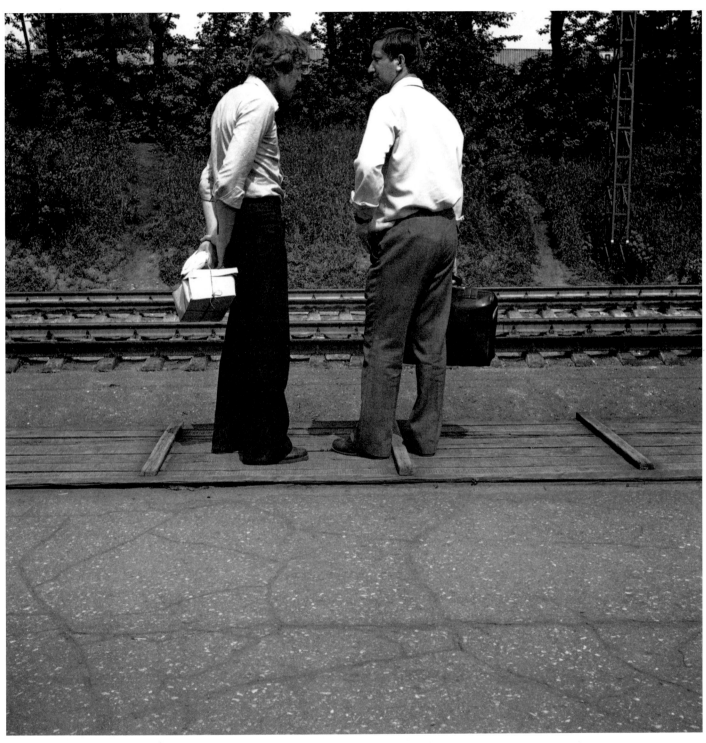

Alexandr Slyusarev, *Leningrad* 1983

People and Ideas

This past spring a group of Soviet documentary filmmakers visited New York in conjunction with the opening of the "Glasnost Film Festival," a U.S. tour of twenty-two recent documentary films from the Soviet Union. The festival was assembled by Citizens' Exchange Council, an organization which fosters cultural exchanges of various sorts, including photo workshops and film programs, between the Soviet Union and the United States. The following interview by Nan Richardson with filmmakers Leonid Gurevich, Hertz Frank, Sergei Muratov, and Nadezdha Khvorova, with translation by Viviane Mikhalkov, was held in New York on April 1, 1989.

Nan Richardson: Soviet cinema and photography have always been distinguished by powerful images propelled by a sense of political and social reality—one has only to mention Sergei Eisenstein, Dziga Vertov, Alexander Rodchenko to bring them to mind. Can you comment on the still image and its relationship to the changes of perestroika? Has content come to dominate the image?

Leonid Gurevich: It is obvious that there is a link between the image and the word. But this is only one side of the process. Many ideas have to be debated today, and words alone are not sufficient to express them, though words are often given a principal role. Most films can be termed "image" films or "word" films. But even in word films, where the emphasis is on the narration, on the information, words alone are not sufficient—they need to be accompanied by a strong image. Unfortunately, one of the diseases of our cinema is that it is too verbal, too wordy; the image is often seen

as secondary, not having the necessary impact. It is hard to find films where the language and image are really equal components of the whole. Among the documentaries recently shot in the Soviet Union are a few where the image is dominant—*The Evening Sacrifice, Adonis XIV, Scenes at the Fountain,* or Hertz Frank's *High Verdict.*

Hertz Frank: *High Verdict* is a very bad translation of the title of my film; it should have been called *Last Judgment.* You know, it was shot in one take, as the Lumiere brothers used to do. It seemed appropriate as a form, because the human face is a seismograph of the soul.

Sergei Muratov: As one Polish writer put it, the most beautiful landscape on earth is the human face.

Frank: That's why it's so important to have a good photographer on the set. I took pictures myself, and had one photographer, a very famous photographer, a member of the Soviet League of Photographers. Look, here are the photographs he took for *Last Judgment,* and the ones I took. Do you see the difference? It is very important to notice that cinema and photo pictures are very different, the mood is different, the staging is different. From time to time during the making of the film, I would take a picture myself—totally different from the image I was shooting. All these pictures represent everyday life in jail. I came to cinema from photography, and I feel a very strong connection between the two—in fact, I learned everything from being a photographer. Photography is as good as a diary.

Muratov: To return to this comparison between the landscape of a human face and the importance of photography, of the image, I think we have to consider two films, *Evening Sacrifice* and *Last Judgment.* In *Last Judgment,* the protag-

onist is a man facing the last minutes of his life, whereas in *Evening Sacrifice* the protagonist is the face of a crowd, and in the film *Adonis XIV* the face of the goat, which actually is the face of what could be called "an innocent traitor," a human being who betrays another. Actually, a lot of people have said that this goat was a great actor. Have you seen the film?

Viviane Mikhalkov: Yes, it's the story of a goat that leads other animals to their death, to the slaughterhouse.

Richardson: With perestroika, literature seems to have acquired a strong journalistic aspect. Has something similar happened in cinema? Has perestroika refocused interest on documentary films?

Gurevich: One could say that our country is basically experiencing two revolutions. One is occurring in the news, in journalism—it has now become more interesting to read the papers than to live real life. But what about the cinema? In feature films, I would say that so far perestroika has produced only one film, *Repentance.* We have no other feature film of such importance. But as far as documentary is concerned, we have had another revolution. The world has completely opened itself to us, thanks to documentary cinema. The camera has studied aspects of life that were previously forbidden. Documentary filmmakers have revealed chapters of our past that were not allowed to be shown before and scenes of our present which had never been visible earlier: drug addicts, jails, prostitutes. All scenes of life have now been opened up. And, in a sense, this revolution all started with Yuri Podnyetsk's film, *Is It Easy to Be Young.*

Mikhalkov: Wasn't *Is It Easy to Be Young* awarded best documentary in America in 1987?

Muratov: The film has received so many

awards! More importantly, documentary filmmakers are now using their films to throw themselves into reality. They have stopped simply observing and reporting on life and now take part and support the political changes. This is only the beginning of our new creativity. As time goes by, documentary filmmakers will go further, but the tragedy is that this form of cinema remains basically unknown to the general audience.

Frank: What Sergei Muratov is describing is a situation of people closeted away like moles till perestroika awoke us. Suddenly Gorbachev came to power in 1985, and here we are, out from our ratholes. But this is not a totally accurate

Richardson: Was *The Forbidden Zone* "forbidden" back in 1974?
All: No. It was just very, very rarely shown.
Frank: Almost no one saw it then.
Muratov: I'd like to say one thing. Before a revolution appears, there must be a revolutionary. What Hertz Frank says is fair. These people were like revolutionaries before the revolution. Practically speaking, they were working underground. Very few people knew about them or about their work. When I talk about revolution in cinema, I mean revolution considered as a social phenomenon, a phenomenon with an echo in the masses.

opinions, because that was what we were working at already, so many years ago.
Khvorova: That's the problem, the balance between aesthetics and the point of view. It's particularly difficult when you're given the freedom to shoot whatever you feel like.
Gurevich: There's a dangerous temptation: fast success. Just take a topic which has been condemned and has never been filmed and you can become a hero in one second. But the work of the artist disappears. Before, we criticized those who simply applauded our reality; now, we are ready to applaud those who only condemn our reality. But real art always

Wilhelm Michailowsky, film still from *Last Judgment* directed by Hertz Frank, 1988

Wilhelm Michailowsky, film still from *Last Judgment* directed by Hertz Frank, 1988

picture. Some of the films we are presenting in this Glasnost Film Festival were made long before 1985, and several of us have been trying to make this kind of cinema for years. Among our delegation, there are two of us (myself and Obukhovich) who have been filming the way we do for more than twenty years. Obukhovich still has movies on the shelf, that have never been seen. Take, for instance, *The Forbidden Zone*, which is about a juvenile jail. Today we see pictures of similar subjects all over the magazines and papers in the Soviet Union. But this particular film was shot in 1974. It's interesting to mention that Yuri Podnyetsk, who made *Is It Easy to Be Young*, worked as director of photography on *The Forbidden Zone*. So to say that we were awakened only in 1985 is really untrue.

Nadezdha Khvorova: In my circle, of filmmakers who belong to a much younger generation, we know we have been given more opportunities. But after awhile, we had a feeling of having eaten too much and too fast. I don't think that the audience feels it has eaten its fill yet, but we young authors do feel that way, and I believe we are in a crisis right now. Because it is simple and easy to film on a superficial level, whatever milieu you choose to film. But to penetrate deeper, to understand a subject and give a proper interpretation of it, is really a different story.
Frank: Those of us who were forbidden to work twenty years ago, and now have movies being taken down from the shelf and shown for the first time, believe it is very difficult to concentrate, to find the exact balance between aesthetics and

has its own tasks and develops according to its own laws. I don't want to give the impression that documentary filmmakers are willing to remain in their ivory tower, nor give the opposite idea that we are slaves to power. Before, we were supposed to help one authority—and now we are supposed to help another. We are facing a time of dangerous crisis. There is too much junk all around. Everybody feels it already.
Richardson: How are documentary films viewed in the Soviet Union? What kind of audience goes to the theater?
Gurevich: The situation is very difficult. Not many people go to see documentaries, even though today documentaries are more popular than feature films.
Frank: Because they give a realistic view of how things are going.
Gurevich: Yes. But the films are poorly

distributed, and the public does not know where to find them. There are not many specialized film theaters for documentaries.

Richardson: Are they shown on TV?

Gurevich: Yes, they are, increasingly, thanks to the efforts of the Union of Cinema. Quite a lot of the documentaries are now shown on TV. But they are released chaotically; they are not presented in retrospectives, in series, in festivals. They are never advertised, and people often don't know what night they're on.

Richardson: What about small theaters?

Gurevich: They're shown in small theaters, but not enough copies are re-

fessional interests. You can be a member whether you are working or not. I think there must be 6,000 members of the Cinema Union.

Muratov: And probably a third of them are documentary filmmakers.

Gurevich: Perestroika has brought one big change in this regard: the Cinema Union now feels that it is its duty to defend the filmmakers' interests—their professional interests and their way of life. From the government, I mean. The Union has made everything possible—it has enabled us to get films that were previously banned into the theaters. The Union fights to defend films that are attacked—films not released by the Minis-

highest level of power (meaning the Central Committee). And that is when the Cinema Union will again defend the film. We had a problem just like this last week. A film had been accepted by Goskino, and had received approval, but it was not released on TV or in theaters thanks to the second in command, Ligachev. And so no one is allowed to see the film. The Cinema Union has decided to take up the battle for this film's release. And we will fight Mr. Ligachev's censure.

Richardson: What will happen to perestroika five years from now?

Gurevich and **Muratov** (laughing): This is a question every journalist asks us!

Hertz Frank, film still from *Last Judgment* directed by Hertz Frank, 1988

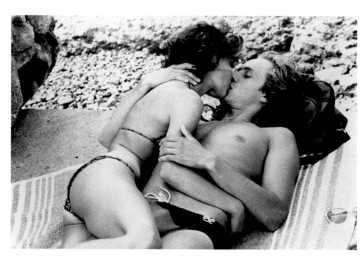

Film still from *Little Vera*, directed by Vasily Pichul starring Andrei Sokolov and Natalya Negoda, 1988

leased. We wish we had access to more theaters, because, basically, theaters that specialize in documentary films are to be found only in the big cities. We are very unhappy with the way our films reach the public and want to change the distribution system. We want to have specialized theaters, organized programming; we want to raise ticket prices. Tickets to nonfiction films are still very cheap, only 30 kopecks (45 cents). We must raise it to one ruble ($1.50). Our "social awareness" leads to the thought that if something is cheap it has to be bad! And then, too, glasnost has not brought any new sources of financing, other than the ones we had previously.

Richardson: What is the status of documentary filmmakers? How are the unions structured?

Gurevich: The Cinema Union is a trade union of people linked by the same pro-

try of Cinema (Goskino). And this kind of conflict happens often enough.

Richardson: Tell me more about how a film gets released.

Gurevich: Our cinema is state cinema. Before, the Ministry of Cinema was the body responsible for approving or forbidding the release of a film. Nowadays, it is often the producing studio which is in charge of that. It is only when the studio has doubts about a film that it asks Goskino to take care of the release procedure. But now, basically, Goskino works hand in hand with the Union. Goskino is a government agency, whereas the Cinema Union is a trade union organization. If Goskino (for whatever reason) prevents the release of a film, then the Cinema Union will fight this decision. Today Goskino rarely prevents a film's release. If there are real problems, they are taken care of at the

Gurevich: I have no idea how things will be five years from now. I only know that I will do my best to help perestroika continue. Because there is a danger it might not. That danger exists because the freedom we have acquired in ideology will not necessarily extend to the economic arena. Perestroika is supported mostly by the intellectuals who are still prepared to accept living a constrained life, to cope with the lack of material goods and so on. But the working class may not have the same patience. That's why it's impossible to predict what will happen five years from now. Our society is not quiet. We have a lot of problems, and we documentary filmmakers have a lot to do.

Richardson: Do you have a sense of urgency?

Muratov and **Gurevich:** Of course.

Gurevich: We are expecting success in

every area, and success has not come yet. And our people have lost the patience to wait for a better life.

Muratov: Hope will come with the next generation. I don't believe that economic success will solve every problem. I believe that the ideological success we are achieving is most important. More and more foreigners are visiting our country, and I don't think they are coming to see what is on sale in our shops. They come to see who and how we are. I believe that the biggest revolution brought about by perestroika has occurred in our social mind. We have stopped believing in the power of the regime and we are trying to start believing in ourselves. The

many things are happening in our culture, from so many different sources, moving into so many directions and turning things inside out. It's an inward movement, whereas the 1917 Revolution was an outward movement.

Take, for instance, phenomena like the Russian avant-garde during the years of the Revolution—we do not have any equivalent to that now. Although today artists express themselves a lot, they do not bring anything so essentially new to our culture. They do not have the energetic impulse that characterized their counterparts at the beginning of the century. Their energy loses itself in too many directions. The public today is

generation now in their twenties. If they are able to acquire faith, I will put all my hope on them.

One last remark—it's not by chance that there's now a feature film called *Little Vera.* The title is a play on words: the name "Vera" means "faith." The film isn't called *Little Vera* because the main character, Vera, is short; it's because she has very little faith in life.

Muratov: I agree with Leonid Gurevich that in the '60s everyone wanted to grasp every possibility offered. And if we had not been stopped from embracing the world, I am sure we would be living in a very interesting society now. But I also want to say that the whole world

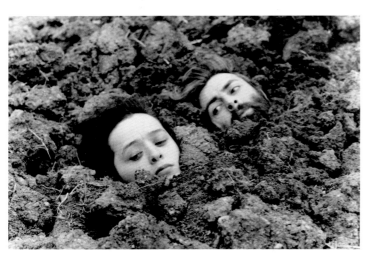

Film still from *Repentance,* directed by Tenghiz Abuladze, 1987

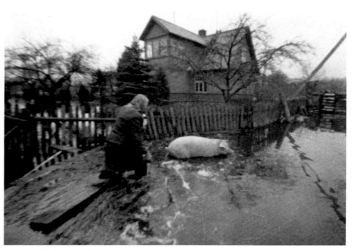

Film still from *The Dugout* directed by Mark Soosar, Tallinn Film Studios, 1988

results of the recent elections have shown just how fast changes have occurred.

Richardson: In a way these changes seem to be like a second revolution. How do the ideas of revolution and the image feed one another?

Gurevich: The link between the idea of revolution and the idea of the image exists, of course, but we must recognize that the 1917 Revolution was accompanied by a revolution in aesthetics. I would not call today's upheavals a revolution. They are not accompanied by an explosion in new discoveries in aesthetics, as in 1917. Up until now, we have not witnessed real changes in art's development or possibilities. Let's say that what we are seeing today is a pluralistic approach to the image. The new freedom is characterized by the fact that we can approach things in diverse ways. So

also more skeptical and the relationship to everything is based on consumer satisfaction. Our hierarchy of values is not only very different from that of the beginning of the century, but it is also totally mixed up.

Of course I share Sergei Muratov's hope that one day a new generation will come along that will have confidence in itself. But I do not believe it will happen soon. Because if the older generation is going along with the dreams and the hopes of the 1960s, if we have been, until now, strong defenders of that period we call "the thaw," we also know there is a risk that everything may fall apart. Today we have been given a second chance (at least that's the way we feel), but the generation of people who are in their forties think we're crazy. What they want is a car, an apartment. And we cannot predict anything about the

looks at the U.S.S.R. today because of what's happening in our country, but they look at us as exotic individuals. It seems to me that what's happening now in our country should not be our concern alone, it should be yours as well. Both in America and in the U.S.S.R., people do not realize that a line has been crossed and that mankind is moving into a totally different dimension. The line was the Chernobyl disaster. Chernobyl was a sort of rehearsal of what awaits us all. Mankind has to understand that everything can be destroyed in a second, and forever. If we want to survive, we have to live according to new rules. We have to live together, make things work together. I get the impression that in America you feel the same way, but do not yet understand what it is all about.

Richardson: But containing the technology of nuclear weapons and power

seems impossible. I read in the papers yesterday that Iraq may soon have nuclear weapons, besides all the other countries that already have them.

Frank: We have one choice: either mankind will be cleverer than before, more intelligent, or it will disappear. I have the feeling that this last option happened once before, a long time ago. And I think that the Bible is the summary of all the reflections about that previous destruction.

Richardson: But we might not have Noah this time! And on that apocalyptic note, we have to stop.

STOPPING TIME
By Nancy Roth

Vanishing Presence, Walker Art Center, Minneapolis, January 29–April 16, 1989.

This expansive, ambitious exhibition examines how a certain set of formal effects, including blurring, multiple exposure, and selective focus, achieve aesthetic effects in photographs. Embracing an imposing range of work, early and late, large and small, daguerreotype to Polaroid, it attempts far more than the description of a new trend, more even than the outline of a certain kind of photographic meaning. Its scope—roughly, every kind of photograph that is *not* "straight"—suggests nothing less than an alternative photographic aesthetic, something to challenge, or at least radically expand, the reigning system of values in which the sharply focused single image qualifies as the best, most "essentially photographic" kind of picture.

In his catalogue essay, curator Adam Weinberg argues that clear, focused representations imply a clear, orderly worldview, the sort of view which assigns people and things fixed names and locations, characteristic possibilities and limitations. The blurred image, on the other hand, suggests various kinds of ambiguity and uncertainty, and the possibility of change. In photography's early years, blurs were considered flaws, disturbing because they "suggested the limitations of nineteenth-century technology and, consequently, the limitations of

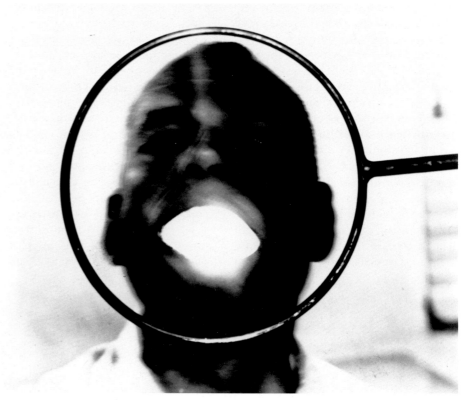

Dieter Appelt, *Prasenz der Dinge in der Zeit,* 1985

human control over the economic, social, cultural, and physical environment." Now, however, such ambiguity or indeterminacy is assigned positive value. The contemporary artists featured in this exhibition specifically "*encourage* [emphasis mine] us to see that our lives are uncontrolled and unpredictable." Weinberg attaches political significance to these distinctions: the focused, still image corresponds to a striving for fixed, hierarchical order; the blurred image corresponds to some level of resistance against such order.

The exhibition is divided into two unequal parts; a small historical segment and a large contemporary one. The historical section builds the case for a long tradition of un-straight photography, reaching back to the very invention of the technology. Some of those who made such images used the effects deliberately, as in Julia Margaret Cameron's use of soft focus to generalize the specific features of her sitters into universal human types. But most did not. Louis Daguerre, Thomas Annan, and Alexander Gardner understood blurring to be an error, though not such a serious flaw as to destroy the picture. Weinberg presses them all—deliberate users of the blur,

commercial practitioners and amateurs, scientists and esthetes—into his new structure.

The heart of the exhibition is the contemporary work, where twelve photographers are represented: Dieter Appelt and Bernard Blume (both of West Germany), Mary Beth Edelson, Joseph Jachna, William Klein, Ralph Eugene Meatyard, Duane Michals, Lucas Samaras, Francesca Woodman and Anne Turyn (all Americans), Michael Snow (Canada), and Patrick Tosani (France). The artists are of different generations as well as varying levels of experience and perceptive range. More to the point, their use of the formal devices in question defies generalization. Intriguing lines of continuity might certainly be drawn. One might contrast the extended self-portrait of the prolific, self-assured Lucas Samaras with the restrained and self-conscious probings of a very young woman, Francesca Woodman. Woodman's work, in turn, might be compared with the very different ideas about identity, time, and repetition taken up by Mary Beth Edelson. Duane Michals's manipulations of narrative sequences could be held up against the very subtly altered repetitions of Dieter Appelt, or

Anne Turyn's explorations of memory against Bernard Blume's constructed dramas. Still, the overall structure remains fragmentary.

Such determined open-endedness may leave viewers confused, or simply content to consider isolated parts of the exhibition without troubling too much about the whole. But it is exactly *as a whole* that *Vanishing Presence* presents its greatest challenge. For if this exhibition fails to describe an alternative "non-straight" aesthetic with adequate rigor and detail, it does raise the possibility that such a thing *could* be done. Such an aesthetic, of course, is very like the one it proposes to supplant: the criterion "unstraightness" provides just as adequate a basis as "straightness" does for pulling photographs out of context, insisting on a purely aesthetic consideration. And in fact this exhibition is already vulnerable to such over-familiar criticism. By focusing on the formal category *blurriness*, it can cut through whatever aesthetic or political conflicts these photographs might address independently, producing an appearance of harmony and support for the exhibition's organizing idea.

And yet, at another level, the idea of an alternative aesthetic is something more than old wine in new bottles. For if one alternative exists, so could other aesthetics, other ways of organizing the history and judging value in photographs. Aesthetics could be as plentiful as viewers, one no more or less valid than the next, and virtually any photograph might qualify as art, might be considered for a place in a museum. At such a moment, the museum's authority, its position as arbiter of what is good, is undermined.

Vanishing Presence, the appropriate and rather poetic title of this exhibition, hints at the way blurred images achieve their various meanings in the first place, namely by contrast with the expected, with "straight" photographic representation. The same conventions of focus and clarity that reliably register "presence" to us also allow for blurs to register an opposing meaning, such as "vanishing." Similarly, it is the presence of a straight aesthetic that allows us to even consider the possibility, the shape, the meaning of an "unstraight" one. In posing this question, *Vanishing Presence* is

eroding the basis for distinctions and judgments that constitute an aesthetic—it is, in short, undermining its own position. What's vanishing, finally, are fixed, reliable, "museum-quality" criteria for judging photography as art.

BETWEEN TWO WORLDS
By James Yood

Photems: A Collaboration by Gerlovina/Berghash/Gerlovin, Art Institute of Chicago, April 29–June 25, 1989.

Few things are more disarming than seeing multileveled and complicated concepts presented and defused in a direct and openhanded way. Therein lies the fascination, charm, and ultimate success in the collaborative work of Rimma Gerlovina, Valeriy Gerlovin, and Mark Berghash, who conceive, paint and photograph a succession of linguistic curiosities, mathematical oddities, and as-

sorted ambiguities, ambivalences, and conundrums with panache.

The husband and wife team of Valeriy Gerlovin and Rimma Gerlovina emigrated to the U.S. from the Soviet Union in 1979, where they were—as colleagues and individuals—in the forefront of the underground conceptual art movement known as Samizdat, or "self-publishing." They met photographer Mark Berghash in New York in 1985, and soon after began the ongoing collaboration that they've called "Photems," telescoping the words "photography" and "totem."

Using the tactic of body painting, one of the more primitive and direct forms of human expression, Gerlovina/Berghash/Gerlovin spin out rebuses of textual play that test both language and perception, subtly undercutting both. In most instances Gerlovina's impassive and almost Pre-Raphaelite face becomes the pictorial field for Gerlovin's "inpainting" of their adopted language, which is

Gerlovina/Berghash/Gerlovin, *Magic Square,* 1987

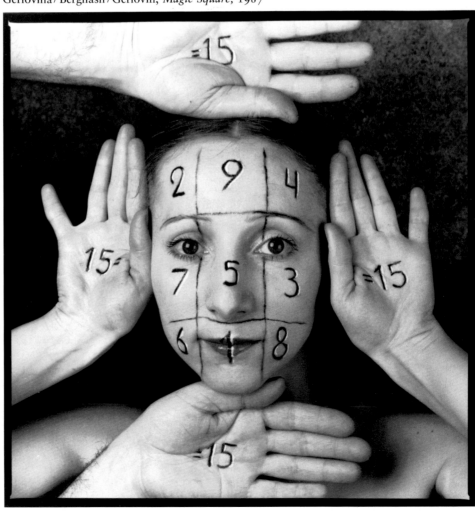

then photographed by Berghash. *Magic Square*, 1987, is an odd mix of tic-tac-toe and cabalistic numerology in which the figures 1 through 9 are arranged in three rows across Gerlovina's face so that in each direction the sum of 15 is achieved, (indicated by her two hands and two of her colleagues'). It is absurd, amusing, oddly mesmerizing, an exercise in the fanciful and the concrete that fixedly holds our attention. In *Neck of Alphabets*, 1987, Gerlovina's throat is adorned with painted linguistic chokers that take language from its pictographic roots in hieroglyphics at the base of her neck through subsequent permutations—cuneiform, Hebrew, Chinese, Arabic, Sanskrit, Greek, and Roman—to the "abstract" lettering of modern-day Russian. Pattern and content freely intermingle as our constructs, the structural component elements of our shared system of understanding and communicating, become elegant fodder. And in *I AM MORTAL*, 1988, Valeriy Gerlovin sticks his finger, painted with the scarlet letter A, amongst the word "Immortal" that is painted across his pate. Punning, clever, and unabashed, Gerlovina/Berghash/Gerlovin deconstruct to reconstruct, and vice versa.

Dan Weiner, *Exercise Class, Park Forest*, 1953

BACK TO THE FUTURE
By Steve Dietz

America Worked: The 1950s Photographs of Dan Weiner, by William A. Ewing, with an introduction by Lionel Tiger. Published by Harry N. Abrams, New York, 1989 ($39.95 hardcover).

America Worked is funny enough to make you laugh aloud while looking at the pictures. There's also a serious side to Weiner's pictures, but as when listening to a Garrison Keillor story, the reader is lulled into a self-deceptive complacency about "those" people: housewives at a Park Forest kaffeeklatsch, executive stenographers on the golf course, commuters enjoying the swimsuit fashion show on the five o'clock train. These images, buttressed by period quotes from *Fortune* magazine, William Whyte's *Organization Man,* and Vance Packard's *Hidden Persuaders,* culminate in an almost sheepish nod of recognition by the reader that 1980s America, with

its yuppies, Reaganomics, and power breakfasts, may be only a kind of morning-after hangover of the no-longer-so-funny hubris of 1950s America.

It has been said that forgeries nearly undetectable in their own time become, with the passage of years, transparently obvious. Whether he knew it or not, Weiner was isolating such foibles for a context (*Fortune* magazine) that used them to prop up precisely what is stripped bare in *America Worked*. Weiner points to what amounts to an empire with no clothes.

The America we see naked in *America Worked* does not hide its pride, its prowess, or its ignorance. Suburban-corporate life, with strict segregation of roles by gender and economic class (and by race—nonwhite faces are virtually absent), is paraded with a lack of self-consciousness both to envy and to feel sorry for—and perhaps to be angry at. Here the humor does its balancing act. There is something so quaint about the picture of refrigerator shoppers, with its caption predicting "some sort of showdown . . . between the home freezer and the freezer-refrigerator combination," and so eager and wholesome about the scores of suited men, that the laugh-aloud humor is a kind of antidote to any overly didactic reading of the images. Yet according to author William Ewing, Weiner had an

exposé mentality, writing in his diary, "A board meeting suddenly becomes a tense drama, acted out around a mahogany table. Here is greed, aggressiveness, tensions detailed and characterized." And indeed, on page after page, Weiner brilliantly sketches complex social interactions with what seems an amazing economy of means and subtlety of implication. It is difficult to gauge whether such images were viewed critically in their time, within the pages of *Fortune* with its staid executive portraits and portfolio sections that often offered a kind of "capitalist realism" venerating America's vast industrial capacity. In any case, there is no poverty, no rural ramshackle, no urban blight in these pages. The America depicted by Weiner was staunchly suburban, white, middle class, and familial.

America Worked, through the sequencing of photographs and by pairing them with excerpts from tracts of the time, allows the reader to look at Weiner's pictures from two points of view—on the one hand, straining to see the bright promise of Henry Luce's "American Century"; on the other, hardly able to believe the affrontery of it all. One wonders whose photographs of the 1970s and 1980s will reveal with such painful clarity what it seems we should have known all along.

CONTRIBUTORS

DMITRI BALTERMANTS, born in 1912, is a Moscow photojournalist who serves on the editorial board of the weekly magazine *Ogonyok*.

OLGA ANDREYEV CARLISLE is an artist and writer who lives in San Francisco. She is the granddaughter of Leonid Andreyev and has published a translation of his short stories, *Visions* (Harcourt Brace Jovanovich, 1987).

NATALYA CHEKHOMSKAYA, born in 1945, studied architecture at Leningrad University. Self-taught as a photographer, she is now director of photographic studies at the House of Culture, Leningrad.

ELENA DARIKOVICH, born in 1951, is a photographer who lives outside of Moscow.

STEVE DIETZ is a book editor at Aperture.

HANNU EERIKAINEN is a media researcher and lecturer in the Department of Photography at the University for Industrial Arts, Helsinki.

HERTZ FRANK, born in 1926, graduated with a degree in law. Formerly a photographer, since 1959 he has worked at the Riga Film Studio as a director, script editor, and screenwriter.

ANATOLY GARANIN, born in 1912, is a photojournalist and longtime correspondent for *Soviet Union*.

IGOR GAVRILOV, born in 1945, is a photojournalist for the Moscow weekly *Ogonyok*.

ALEXANDER GREK is a photographer who lives and works in Moscow.

LEONID GUREVICH, a director, screenwriter, and critic born in 1932, is vice-president of the Moscow-based American-Soviet Kino-Initiative.

FRANCISCO INFANTE, born in 1943, works as a freelance artist and designer in Moscow.

TOOMAS KAASIK lives in Tallinn, Estonia, and is a member of the Photographic Society of Tallinn.

TOOMAS KALVE lives in Tartu, Estonia. He is a member of the Photographic Society of Tallinn.

NADEZHDA KHVOROVA was born in 1956 and graduated from the director's section of the All-Union State Cinematography Institute in Moscow.

VYACHESLAV KOLEICHUK, born in 1941 in Moscow, is an architect.

REIN KOTOV lives in Tallinn, Estonia, and is a member of the Photographic Society of Tallinn.

LYALYA KUZNETSOVA, born in 1946, has been working as a freelance photographer since 1983.

PEETER LAURITS, born in 1962 in Tallinn, Estonia, graduated from Tallinn Technical College as a photographer in 1984.

PEETER LINNAP, born in 1960, is a photographer, curator, and critic who has lectured on photography at the Tallinn (Estonia) Teacher Training College since 1985.

VITAS LUCKAS (1943–1987) was born in Kaunas, Lithuania, and worked as a freelance photographer.

ALEKSANDRAS MACIJAUSKAS, born in 1938, is a photographer for the Lithuanian daily *Vakarines naujienos* (Evening news) and a member of the Lithuanian Society for Creative Photography.

HERKKI-ERICH MERILA is a photographer who lives in Tallinn, Estonia, and is a member of the Photography Society of Tallinn.

BORIS MIKHAILOV, born in 1938, works as a professional photographer in Kharkov, Ukraine.

INGE MORATH is a photographer and member of Magnum. She has published numerous books including *In Russia* (Viking Press, 1970), and *Portraits* (Aperture, 1986).

DANIELA MRAZKOVA is a photo editor, critic, and curator who lives in Prague. She is a former editor of *Revue Fotografie* and has published numerous books.

SERGEI MURATOV, a film critic and author, teaches in the Department of Journalism of the Television and Radio Division at Moscow State University.

A. NIKOLAEVA is a photographer who lives and works in Leningrad.

ROMUALDAS POZERSKIS, born in 1951, works as a professional photographer in Kaunas, Lithuania.

ROMAN PYATKOV, born in 1955 in Kharkov, Ukraine, works as a publicist and freelance photographer.

ROMUALDAS RAKAUSKAS, born in 1941, is a photographer for the magazine *Nemunas* in Vilnius, Lithuania.

NAN RICHARDSON is a writer who lives in New York, and a former editor of *Aperture*.

NANCY ROTH is a writer and critic who lives in Minneapolis.

ROSALINDE SARTORTI has a doctorate in the social and cultural history of the Soviet Union from the Free University of Berlin, and is currently a senior fellow at the Harriman Institute, Columbia University.

BORIS SAVELEV, born in 1948, works as a freelance photographer in Moscow and recently published a book of photographs entitled *Secret City: Photographs from the USSR* (Thames and Hudson, 1988).

ANTANAS SUTKUS, born in 1938, is a cofounder of the Lithuanian Society for Creative Photography.

KALJU SUUR is a photojournalist for *Sirp Ja Vasar*, Tallinn's leading daily newspaper, and a member of the Estonian Photographic Society of Tallinn.

ALEXIS TITARENKO is a photographer who lives in Leningrad, and a member of the Leningrad Photo Club, "Mirror."

TONU VALGE is a photographer who lives in Tartu, Estonia, and is a member of the Photographic Society of Tartu.

JAMES YOOD is an art historian and critic in Chicago.

GEORGI ZELMA (1906–1984), born in Tashkent, Uzbekistan, was a frontline correspondent for *Izvestia* during World War II.

VLADIMIR ZOTOV, born in 1932, works as a photojournalist for the evening paper in Kazan.

CREDITS

NOTE: In the following credits, dimensions are given for prints 20 × 24″ or larger, with the height listed first. Special or unusual processes involved in making the work are also listed. Unless otherwise noted, all photographs are courtesy of, and copyright by, the artists.

Front cover: photograph by Antanas Sutkus, courtesy of Daniela Mrazkova; pp. 2–3 photographs by Dmitri Baltermants, courtesy of Magnum Photos; p. 4 (left) photograph by Anatoly Garanin, courtesy of Magnum Photos; pp. 4–5 photograph by Dmitri Baltermants, courtesy of Michael Brainerd; pp. 6–7 photograph by Dmitri Baltermants, from the permanent collection, International Center of Photography, New York; pp. 9–10, handcolored prints by Boris Mikhailov, courtesy of Daniela Mrazkova; pp. 12–13, handcolored prints by Roman Pyatkov, courtesy of Daniela Mrazkova; pp. 14–15, color photocollages by Alexis Titarenko, courtesy of Leslie Goldman; pp. 16–17, manipulated and handcolored print by Herkki-Erich Merila, courtesy of Leslie Goldman, pp. 19–23 photographs by Boris Savelev, courtesy of the artist and VAAP, Moscow; pp. 24–27, photographs by Aleksandras Macijauskas, courtesy of Daniela Mrazkova; pp. 28–29, photographs by Romualdas Rakauskas, courtesy of Daniela Mrazkova; pp. 31–33, photographs by Romualdas Pozerskis, courtesy of Daniela Mrazkova; pp. 34–39 photographs by Lyalya Kuznetsova, courtesy of Inge Morath and Daniela Mrazkova; p. 40, photograph by A. Nikolaeva, courtesy of Leslie Goldman; p. 41 (bottom) photomontage by Natalya Chekhomskaya, courtesy of Daniela Mrazkova; pp. 41–43, multiple exposure prints by Vitas Luckas, courtesy of Daniela Mrazkova; p.44, manipulated and handcolored photograph by Rein Kotov, courtesy of Leslie Goldman; p. 45, photographs by Toomas Kalve, courtesy of Leslie Goldman; p. 46, multiple exposure print by Toomas Kaasik, courtesy of Leslie Goldman; p. 47, photograph by Herkki-Erich Merila, courtesy of Leslie Goldman; pp. 48–49, manipulated prints by Peeter Laurits, courtesy of Leslie Goldman; pp. 50–51, multiple exposure prints by Roman Pyatkov, courtesy of Daniela Mrazkova; p. 52, manipulated print by Tonu Valge, courtesy of Daniela Mrazkova; pp. 52–53, photograph by Roman Pyatkov, courtesy of Daniela Mrazkova; pp. 54–55, photographs by Peeter Linnap, courtesy of Leslie Goldman; pp. 57–61, photographs by Igor Gavrilov and Elena Darikovich, courtesy of Daniela Mrazkova; p. 62 (top) and p. 63, magazine-cutout collages by Vyacheslav Koleichuk, courtesy of Daniela Mrazkova; p. 62 (mid and bottom), photographs of installations by Francisco Infante, courtesy of Daniela Mrazkova; p. 64, photograph by Kalju Suur, courtesy of Leslie Goldman; p. 65, photograph by Vladimir Zotov, courtesy of Daniela Mrazkova; p. 66, photographs by Alexander Grek, courtesy of Nan Richardson; p. 67, photograph by Alexandr Slyusarev, courtesy of Daniela Mrazkova; p. 69 (left and right) film stills courtesy of Wilhelm Michailowsky; p. 70 (left) film still courtesy of Hertz Frank; p. 70 (right) film still courtesy of International Film Exchange, Ltd.; p. 71 (left) film still courtesy of Cannon Films, Inc; p. 71 (right) film still courtesy of Leslie Goldman; p. 72 photograph by Dieter Appelt, courtesy of Kicken-Pausebeck Galerie and the Walker Art Center, Minneapolis; p. 73 photograph by Gerlovina, Berghash, Gerlovin, 1987, courtesy of Marcuse Pfeifer Gallery and the Art Institute of Chicago, p. 74 photograph by Dan Weiner, courtesy Sandra Weiner.

"No More Heroic Tractors: Subverting the Legacy of Socialist Realism" © copyright 1989 by Rosalinde Sartorti; "Many Nations, Many Voices" © copyright 1989 by Daniela Mrazkova; "Lyalya Kuznetsova's Scenes from Gypsy Life" © copyright 1989 by Inge Morath; "The Perestroika of Memory" © copyright 1989 by Olga Carlisle; "Dark Light" © copyright 1987 by Peeter Linnap; "Up from Underground" © copyright 1989 by Hannu Eerikainen; "Stopping Time: *Vanishing Presence* at the Walker Art Center, Minneapolis" © copyright 1989 by Nancy Roth; "Between Two Worlds: *Photems:* Gerlovina/Berghash/Gerlovin at the Art Institute of Chicago" © copyright 1989 by James Yood. No part of this publication may be reprinted without permission.

ACKNOWLEDGMENTS

For their invaluable advice and assistance in assembling work for this issue, we thank especially Daniela Mrazkova, Leslie Goldman, and Inge Morath. In addition we wish to express our grateful appreciation to S. Abramov, Fred Baldwin, Miles Barth, Bill Buford, Michael Brainerd, Carol Doerflein, Susan Duca, Carolyn Forché, Birgitta Forsell, Jon Gartenberg, Paul Good, Robert Haller, Daniel Halpern, Josef Koudelka, Paul Lin, Esä Melametsä, Jay Nubile, Gilles Peress, Christopher Phillips, David Shok, Agnes Sire, Robert Stevens, Holger Thoss.

Lee Friedlander

David Graham

Len Jenshel

David Levinthal

Helen Levitt

Joe Maloney

Ray K. Metzker

William E. Parker

Estate of Larry Burrows

Michael Spano

Val Telberg

Susan Unterberg

Catherine Wagner

LAURENCE MILLER
CONTEMPORARY PHOTOGRAPHS
138 SPRING STREET NEW YORK NY 10012 212.226.1220

GOOD AS NEW.

Dropped off cliff while changing lenses in Yosemite National Park, October 1986. Replaced by Leica at no charge: November 1986

Smashed by camera-shy celebrity in June 1987. Replaced by Leica at no charge: July 1987

Dunked in stream while fishing the Alagash Wilderness in August 1988. Replaced by Leica at no charge: September 1988

Dunked and bruised while rafting the Colorado River in early May 1988. Replaced by Leica at no charge: late May 1988

Dropped from third story window in New York City, July 1986. Replaced by Leica at no charge: August 1986

Fell from bleachers at Wimbledon in June 1988. Replaced by Leica at no charge: July 1988

Slammed in car door, August 1988. Replaced by Leica at no charge: September 1988

Trampled by pack horse in High Sierras, August 1987. Replaced by Leica at no charge: September 1987

Run over by Land Rover while on safari in Kenya, January 1985. Replaced by Leica at no charge: February 1985

Smashed against side of helicopter in February 1989. Replaced by Leica at no charge: March 1989

Quite simply, Leica cameras and lenses are the finest in the world. They are the only instruments made with the impeccable precision and legendary optical performance that have earned them an unequalled reputation for photographic excellence. Not only have they proudly survived the unforgiving tests of time, their exceptionally rugged design enables them to survive almost anything. However, there are some things that even a Leica can't survive intact, such as a free-fall off a 2,000-foot cliff. That's why Leica provides its registered owners* with an exclusive, No-Fault *Passport Protection Plan*—a 3-year warranty** against breakage, water damage, fire, and accidents of any kind whatsoever!

So it doesn't matter who, or what, destroyed your Leica. **We'll repair it or replace it free—no questions asked. Just send us the pieces. This extraordinary "product insurance" is available only at authorized U.S.A. Leica dealers.** It's one of the many notable advantages that make owning the world's finest photographic equipment so desirable. For more information about our superb cameras and lenses, plus full details on our Passport Protection Plan, see your nearest authorized U.S.A. Leica dealer. Just call us for his name at 1-800-222-0118, Dept. CP-28-11

Leica

Trademark
of world-famous products
from the
Leica Group

Leica USA Inc., 156 Ludlow Avenue, Northvale, New Jersey 07647

*Leica warranty/registration cards are provided *only* for Leica products imported and distributed by Leica USA Inc.
**Applies to first three years of ownership. Does not cover loss or theft.

Leica USA Inc., 156 Ludlow Avenue, Northvale, New Jersey 07647

While Hasselblad has slept, Rollei has turned dreams into reality.

Hasselblad® has made essentially the same wonderful cameras for decades. Yet, technological advances have made much higher medium-format performance possible.

Rollei has turned these possibilities into realities and embodied them in the 6000 series cameras, extremely advanced Zeiss and Schneider lenses, and accessories that perform a vaster scope of tasks: with greater speed, accuracy, control and ease-of-use.

While Hasselblad has evolved dedicated flash and such, Rollei – in the new 6008 model – has introduced 13 medium-format "firsts." For superb accuracy, pick your spots: center weighted multi-zone, multi-spot, or tight-spot readings covering under 1%! Save time when you select auto-bracketing: ±⅔ stop automatically. For situation versatility, switch "modes operandi": Shutter Priority AE mode; Aperture Priority AE mode; and Programmed AE mode; plus Manual Metering. For more exacting control, the leaf shutter

adjusts from 30 to 1/500 stops in ⅓ stop increments; with 2 increments beyond 1/500! Now see all and know all: all vital data is numerically displayed within your view yet not in the "live" screen viewing area.

Discover the benefits of auto ISO speed-settings; exposure compensation from −4⅔ to +2 stops; open aperture metering; 2 frames/second motor drive; a removable action-grip for single hand operation. And more. New Rollei PQ lenses from Zeiss and Schneider (including 80mm 2.0 and 180mm 2.8 lenses!) make a total of 19 Rollei lenses. And every accessory (some enabling photographic "wizardry") is fully compatible between 6006 and 6008 models (except, alas, the neckstrap).

The stuff of dreams is ready to be put in your hands. Don't sleep on it – explore the possibilities at your Rollei dealer.

ZEISS
West Germany

⟲Rollei
fototechnic

We're looking at things from your point of view.

⊞ Marketing Corp.
16 Chapin Rd., Pine Brook, NJ 07058, 201/808-9010

Hasselblad is a registered trademark of Victor Hasselblad Inc.

Linhof gives you yaw freedom of choice.

Kardan Master GTL

Yaw-free indirect displacements

Yaw-free direct displacements

Kardan GT

Linhof has provided professional photographers with "yaw-free" view cameras for decades. And now we introduce cameras that are "yaw-free-er" than anyone's. Both the Kardan Master GTL and the Kardan GT, with telescoping rails, have a new tri-axial movement to yield yaw-free operation via indirect as well as with Linhof's traditional direct displacements. The choice is "yaws." And whichever technique you choose, no view camera system is more convenient to use.

Linhof precision also gives you extreme stability in *any* position: even in 8x10 inches with long bellows extension. An engineering feat other cameras lack.

Both the GTL and GT are available in 4x5, 5x7 and 8x10 models, with conversion and reducing kits to expedite format-changing. The GTL has brass geared rise/fall movements and "L" shaped standards for in-the-film-plane movements. And the modestly-priced GT is "U" shaped without geared rise/fall.

These represent the most sophisticated and technically perfect view camera systems available anywhere in the world. Visit an authorized Linhof dealer and be ready for a pleasant surprise: Linhof long-lasting quality is within your reach.

Linhof
When your decision is precision.

HP Marketing Corp. 16 Chapin Rd., Pine Brook, NJ 07058, 201/808-9010

A R T I F I C E

Eonic Queen, from "Views from the Shoreline," Colorado, 1986
Ruth Thorne-Thomsen.

THE PHOTOGRAPHY OF INVENTION
American Pictures of the 1980s
Text by Joshua P. Smith
Introduction by Merry A. Foresta
Pictures that are *made,* not taken, are the focus of this exciting collection of works by 90 American artists. Copublished with the National Museum of American Art, Smithsonian Institution.
94 illus., 64 in color $39.95

A FOREST OF SIGNS
Art in the Crisis of Representation
Texts by Ann Goldstein, Mary Jane Jacob, Anne Rorimer, and Howard Singerman
A Forest of Signs documents the work of 30 contemporary artists including Jenny Holzer, Jeff Koons, and Robert Longo. Copublished with the Museum of Contemporary Art, Los Angeles.
176 illus., 61 in color $34.95

WATERTOWERS
Hilla and Bernd Becher
Foreword by Reyner Banham
Commentary by Weston J. Naef
Taken over a period of 25 years, these 223 duotone photographs comprise a unique, single-minded and haunting aesthetic.
"The Bechers photograph their subjects dead-on, under hazy or overcast skies, with a view camera that renders every bolt and brick. This is a wonderful volume . . ."—Jane S. Chou, *American Photographer*
223 duotone illus. $50.00

O SAY CAN YOU SEE
American Photographs 1839–1939
One Hundred Years of American Photography from the Collection of George R. Rinhart
Thomas Weston Fels
Distributed for the Berkshire Museum.
84 duotones, 16 color illus. $50.00

Available at fine bookstores or directly from

THE MIT PRESS
55 HAYWARD STREET, CAMBRIDGE, MA 02142